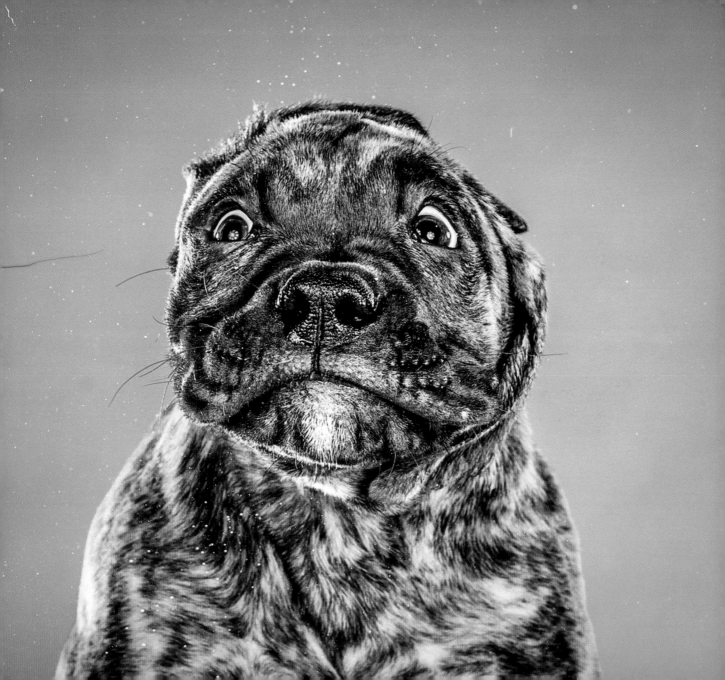

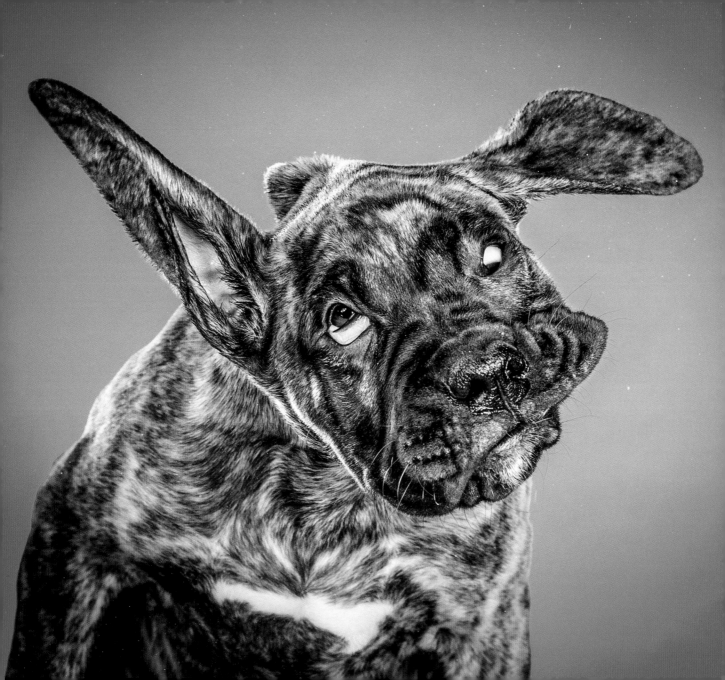

SHAKE
puppies

CARLI DAVIDSON

HARPER
DESIGN
An Imprint of HarperCollins Publishers

HarperCollins books may be purchased for educational,
business, or sales promotional use. For information please e-mail
the Special Markets Department at SPsales@harpercollins.com.

Published in 2014 by
Harper Design
An Imprint of HarperCollins*Publishers*
195 Broadway
New York, NY 10007
Tel: (212) 207-7000
harperdesign@harpercollins.com
www.harpercollins.com

Distributed throughout the world by
HarperCollins*Publishers*
195 Broadway
New York, NY 10007

ISBN: 978-0-06-235172-2
Library of Congress Control Number: 2014936387

Printed in the U.S.A., 2014
First Printing, 2014

To Tim. You make my creativity that much more possible with your all-out crazy awesome love and support.

To Norbert, Yushi, and Saul, who took turns making me laugh over the last year during many long hours of editing. You three constantly remind me to live in the moment.

To Amanda Giese, whose humor and dedication, both on- and off-set, helped me so much in creating this book.

INTRODUCTION

An undeniable wave of emotion comes over me every time I see a puppy. I get on my knees and wriggle. My voice jumps at least two octaves. Something in my heart warms. I see all the potential and curiosity, the desire to learn, the need to play, the search for direction, the trust. Anyone who doubts the emotional intelligence and need for compassion of an animal has probably never spent time with a litter of squirming dogs.

Shooting a book of puppy photographs was an ecstatic experience, and a challenging one. It meant coming home sore after a long day of lying on the floor in awkward positions to get that perfect shot. It meant going out in public covered in the lingering scent of puppy breath. It meant losing feeling in my legs while editing with my canine "clients" asleep in my lap, suckling in their dreams. The shoots were invigorating, despite my relentless schedule. It's certainly the kind of work I'm happy to be stuck with.

The hard part was not photographing the puppies, but coming home and thinking of all the puppies who do not have homes. My heart also sinks at the thought of older shelter dogs who weren't given patience and direction as puppies and who now no longer have the charms of youth to boost their chances of adoption. These shelter dogs are a large proportion of the many millions of homeless animals in this country. They are the ones who were given up on—pushed off to a shelter or set "free," only to find themselves hungry, scared, and alone.

Like the first *Shake* collection, the book of puppy photos you're holding was made to share some laughter and a simple enjoyment of the dogs around us. Seeing dogs at ease is so often the catalyst for inspiration in my own life. The fact that puppies are ridiculously cute and appealing is an axiom right alongside Newton's laws of motion.

If this book inspires you to get a new dog, fantastic! That said, I challenge the initial instinct you may have to buy a puppy from a breeder or store. When it's time to add a canine to your home, please consider a

shelter dog, and one who is suited to be your longtime companion. If you have a particular breed in mind, consider that 25 percent of dogs in shelters are purebred, and your local breed clubs will likely be very happy to help in your search.

Smack in the middle of making *Shake Puppies*, I got baby fever—not shocking, considering that my days were teeming with youngsters. Almost instantly, it became impossible to ignore.

I needed another dog.

As the mother of an elderly dog and cat, I had been considering getting another pet for several years, and had been patiently waiting for the right fit to come along. Some of the puppies I photographed were so tempting, it hurt. But because I was in the middle of releasing two books in two years and shooting nonstop, I had to give my maternal instincts serious consideration. I'm keenly aware that puppies are, by definition, clusters of unbelievably fast-moving atoms who need the full attention of everyone in the room. I questioned whether adopting a puppy would be the best decision. For the time being, it would have to be enough to be the grateful auntie to the sweet babies I fell in love with during the day and then handed back a few hours later.

But when a neighbor of mine mentioned that his friend was in desperate need of a home for the elderly dog who belonged to his ailing mother, I swooped up the dog as a foster. I quickly realized I had found my new—well, slightly used—eight-year-old puppy.

Saul was overweight, matted, and traumatized from the loss of his longtime owner. He also had a form of skin cancer and a significant, but workable, case of separation anxiety that had him barking and panicking when he was left alone. He was not the glamorous "puppy in the window," selling himself with his good looks and devil-may-care attitude, but he was absolutely perfect for my home.

Saul needed patience and reassurance for a few months; slow, consistent training; a better diet; and minor surgery. He did not need house training or training for basic commands (he already knew "sit," "stay," and "come," and was eager to learn more). He also did not need constant behavioral training; he had a calm, adult demeanor. He was perfectly content to sniff stuff and sit on my feet to solicit petting. He found other dogs less interesting than people, so dog-park time was okay, but not required. And his exercise requirements matched my ability to provide a daily walk and backyard play time.

I invested in his health care, a nice cushy bed, some very good dog food, health insurance, a couple fancy toys he completely ignored, and a new leash. I brushed up on my leash-training skills and spoke with a trainer about separation anxiety to see what new techniques were being used to treat it. Ultimately these costs were lower than those of adopting, vaccinating, outfitting, and working with a puppy over the course of two years, and inevitably replacing my favorite pair of boots and a couch decorated with teething marks.

After I had Saul for a day, the fact that he was plump and bedraggled was meaningless to me. Our personalities clicked, and that was all that mattered. I overcame my superficial ideas of what I once thought I wanted my next dog to look like, and I felt good about myself because of it. Still, once he received a fancy haircut and got in shape, I realized I was in the company of a damn fine-looking dog.

The fascinating thing about older pets is that they are simultaneously your children and your elders. My dogs, Norbert and Saul, and my cat, Yushi, are at a time in their lives that I will not reach for many years. Their bodies are changing, at times defying them. They are slowing down, and they especially appreciate the indulgences of sleeping in and being lavished with affection. They teach me what it's like to grow old, to be patient and persevere despite frustrating limitations, and to become more tender with age. While not as dazzling as observing puppies in their frenzied play, watching my own pets in the twilight of their lives is equally touching and emotional.

The biggest lesson I learned from being around the puppies in this book is that the most revolutionary thing you can do to advocate for dogs is to train a puppy from day one. If you can't do that, then adopt an adult dog who fits your lifestyle, regardless of look or breed. Also encourage the spaying or neutering of all dogs, and make sure to do this for your own. Look for a low-cost clinic if money is a concern. Numerous studies support the health and behavioral benefits of neutering before sexual maturity. Bob Barker from the TV show *The Price Is Right* was really on to something: at the end of every episode he urged viewers to spay or neuter their pets. He's a hero in my eyes.

Three statistics really hit home for me while I was working on this book and thinking about baby animals. The first is that every year, millions of dogs and cats in the United States will be given to a shelter or abandoned. The second is that the number-one reason people give up their pets is a lack of training. The third is that the average age for this to happen to these pets is just eighteen months. At that age, a dog suddenly looks like an adult and is challenging its place in the pack (your family), but is actually still young and looking for guidance. Animals have rescued me from depression and trauma many times over the years by patiently listening to me and comforting me. I feel I must do what I can with the platform I have to advocate for their health, safety, and care.

Saul is sleeping by my feet as I write this. His snores, along with my mastiff Norbert's, rhythmically add to the Brian Eno track playing in the background. My house is a calm space because of the demeanor of my laid-back older pets. They remind me to eat well and get outdoors, and with their stern and directed barking, they protect us all from the imminent threat of the mailman.

—Carli Davidson

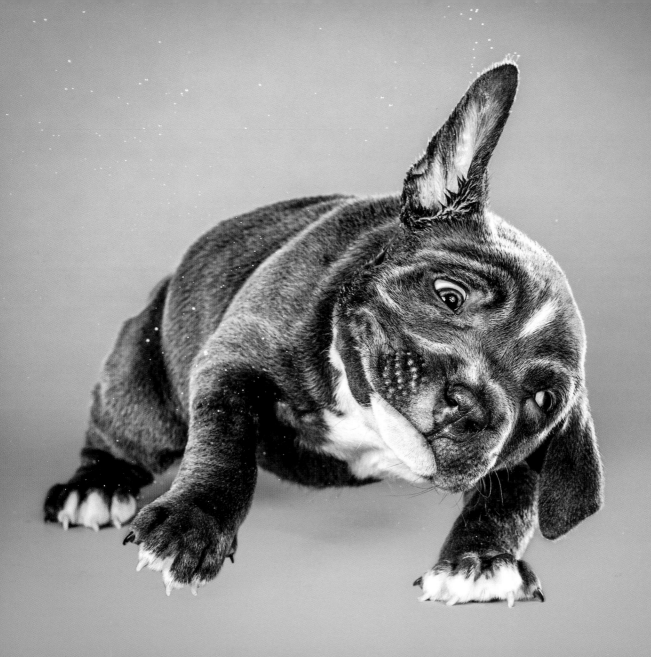

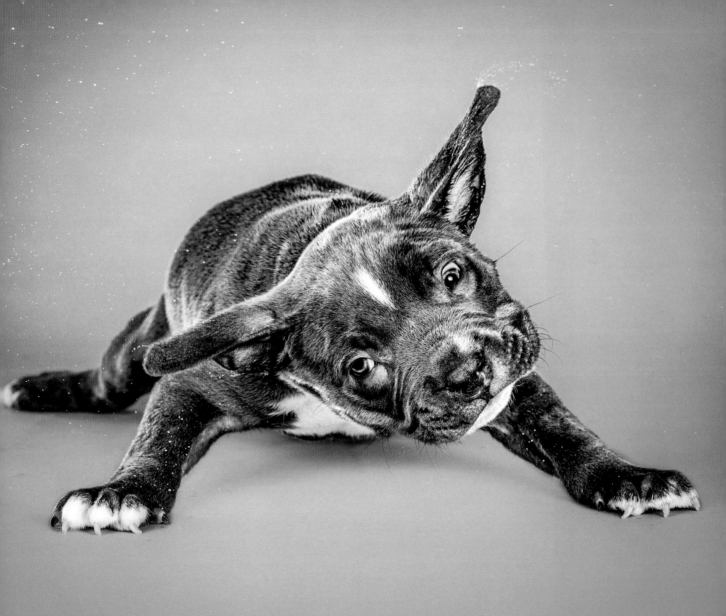

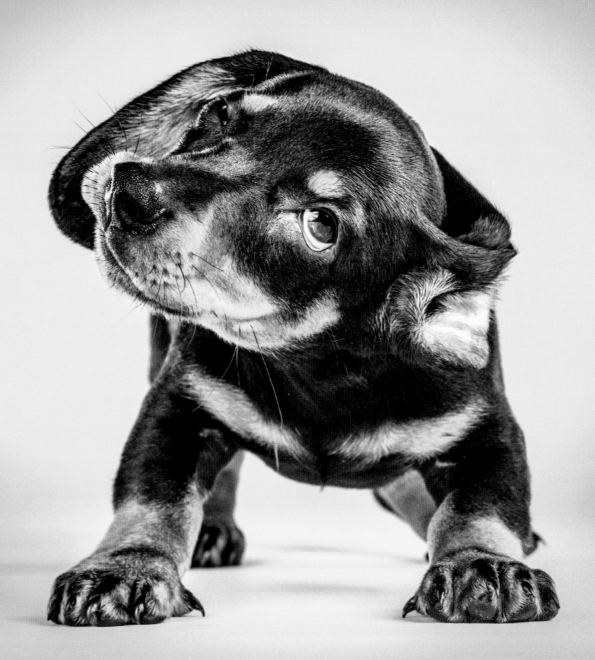

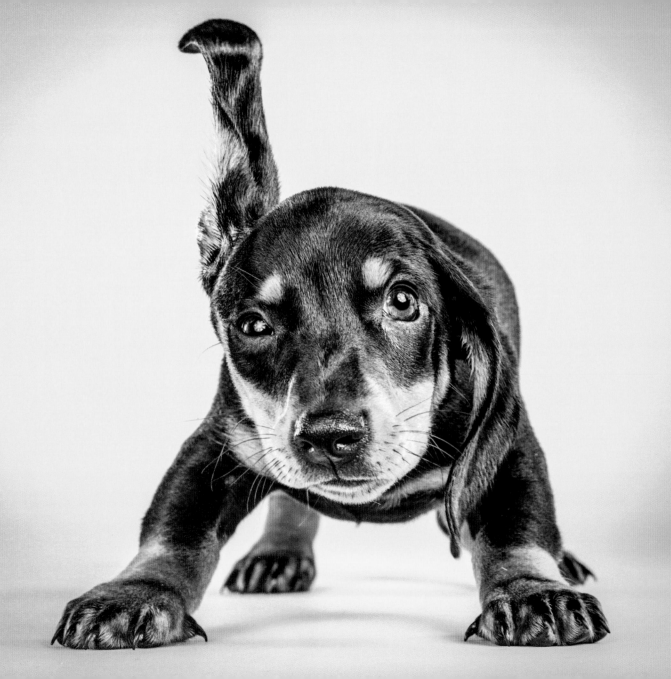

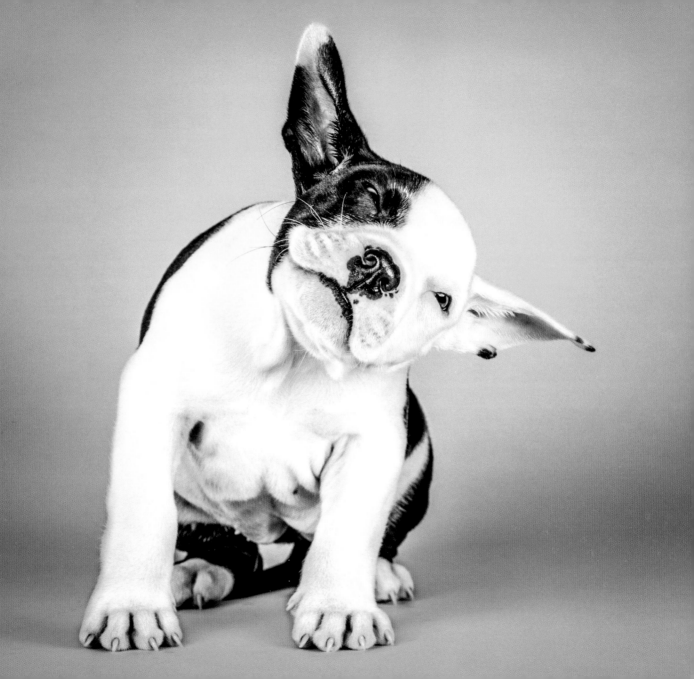

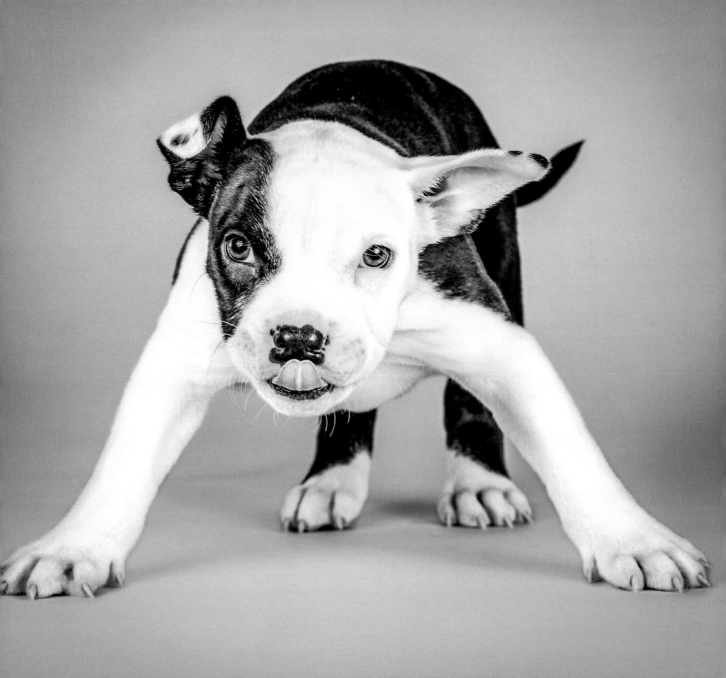

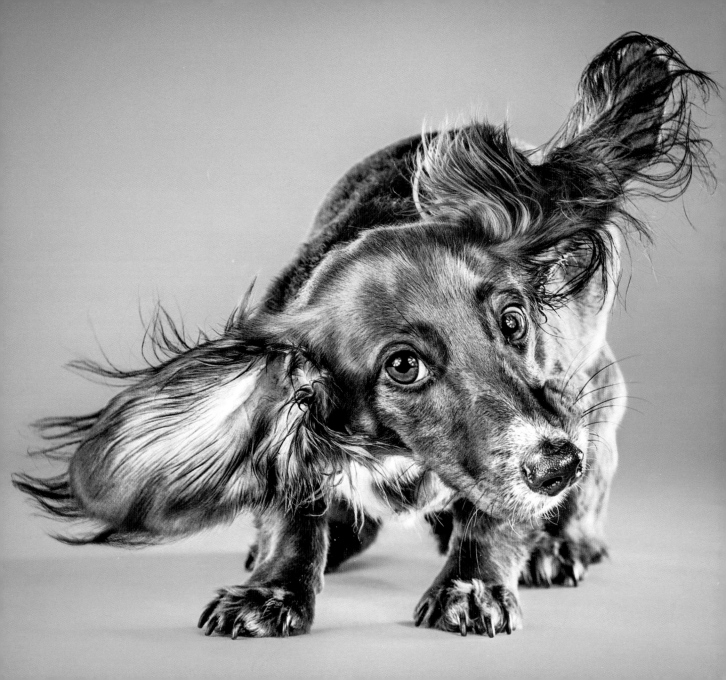

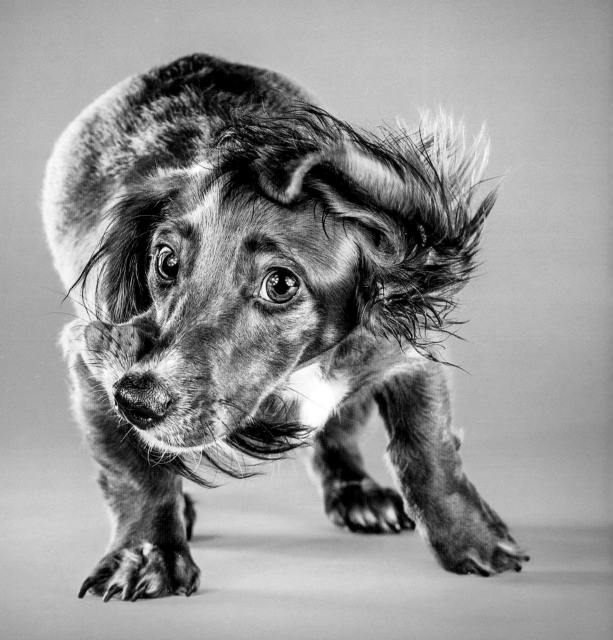

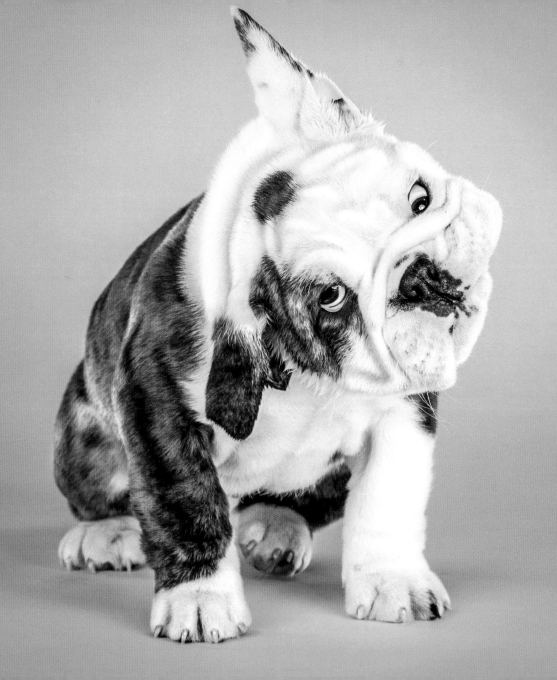

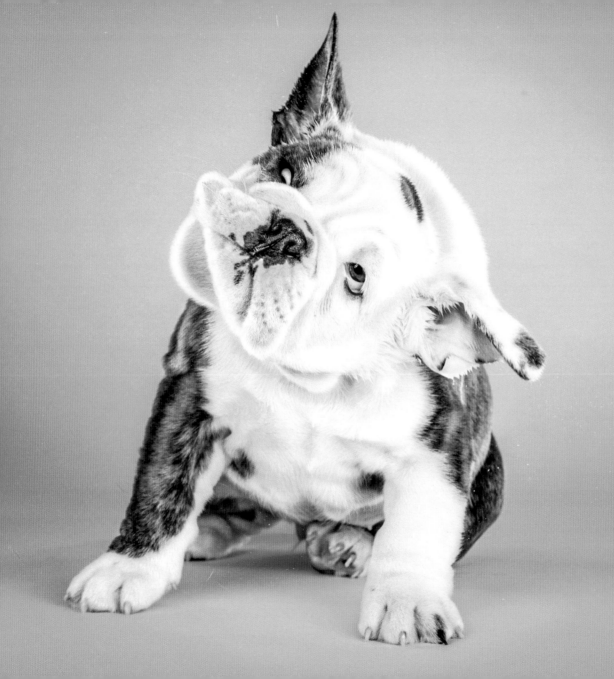

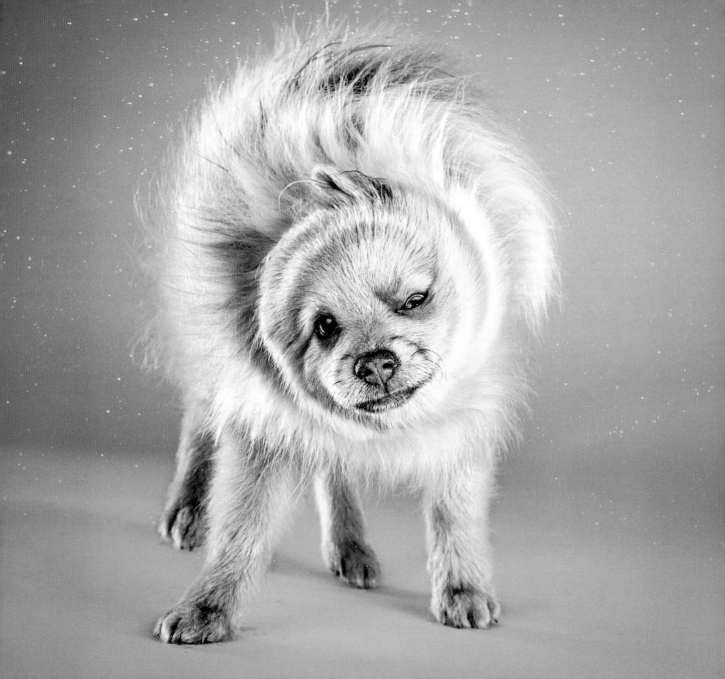

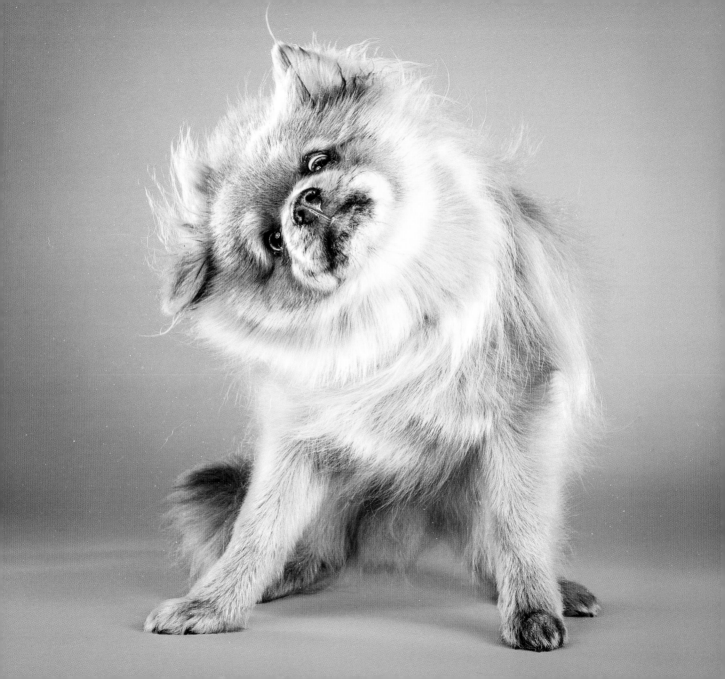

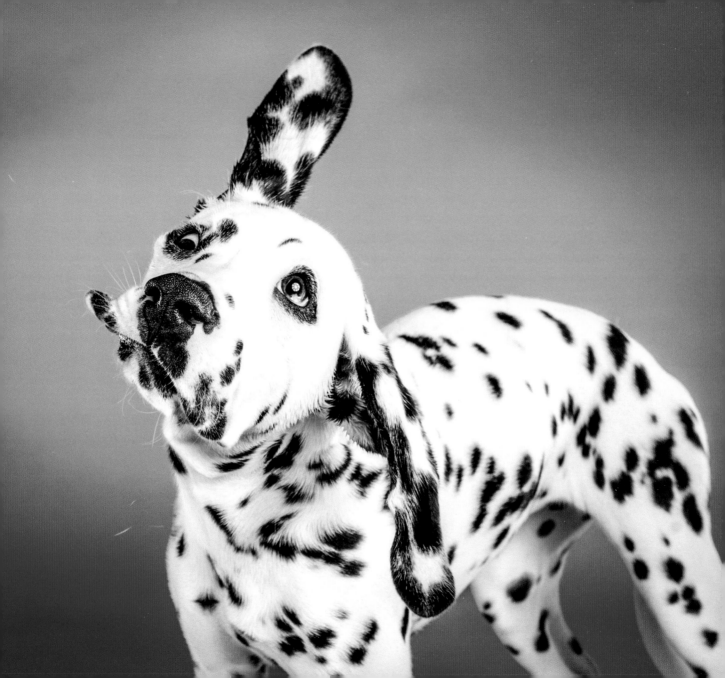

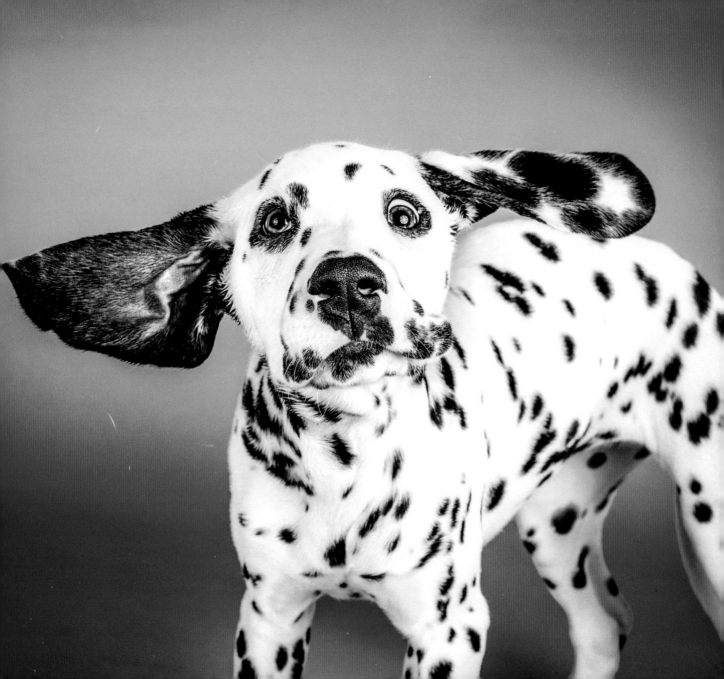

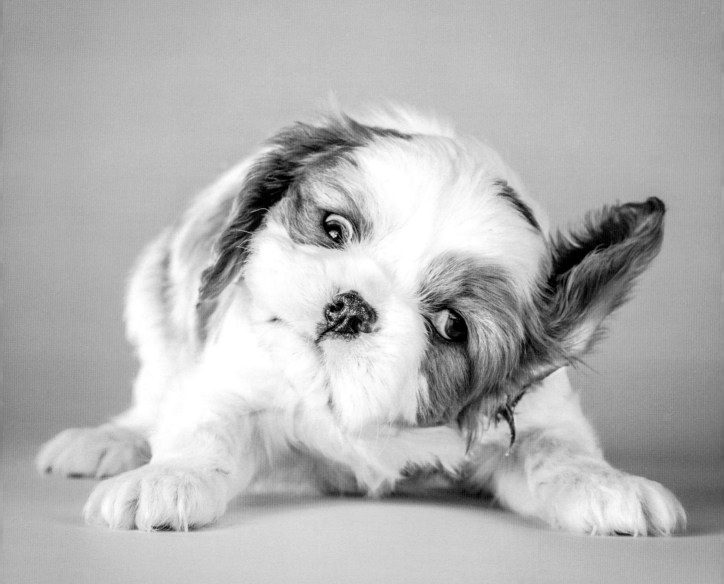

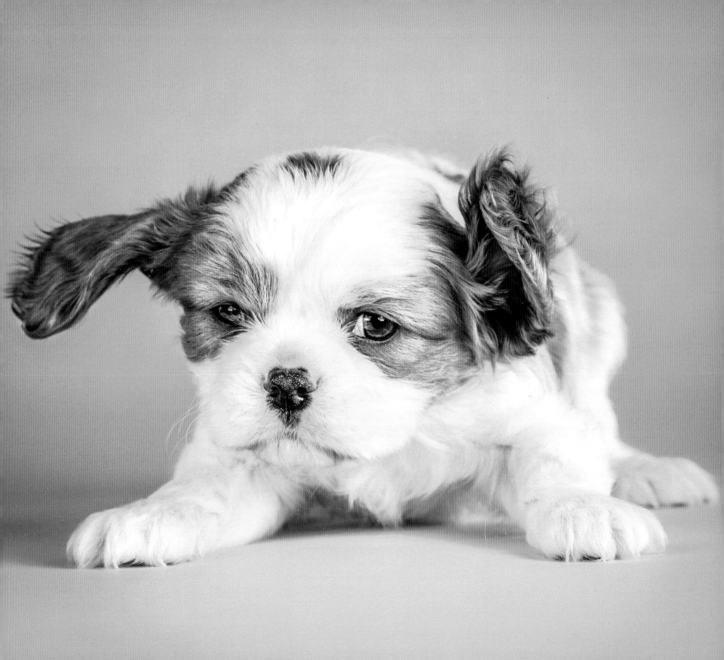

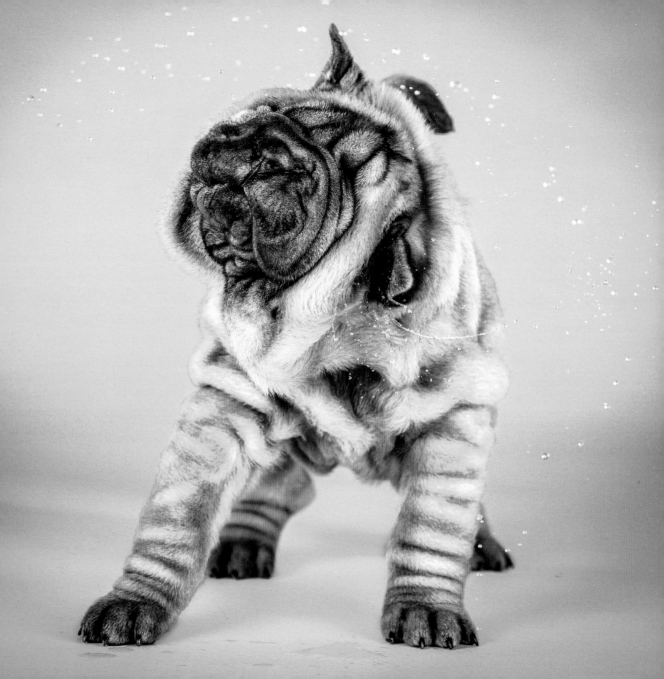

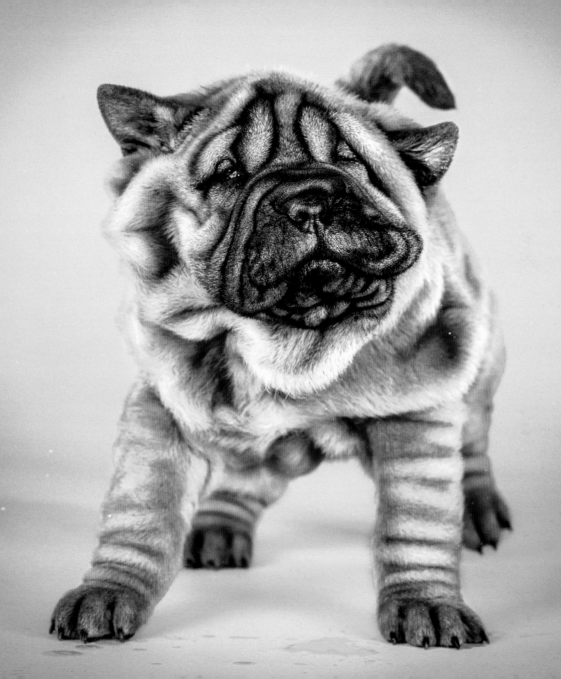

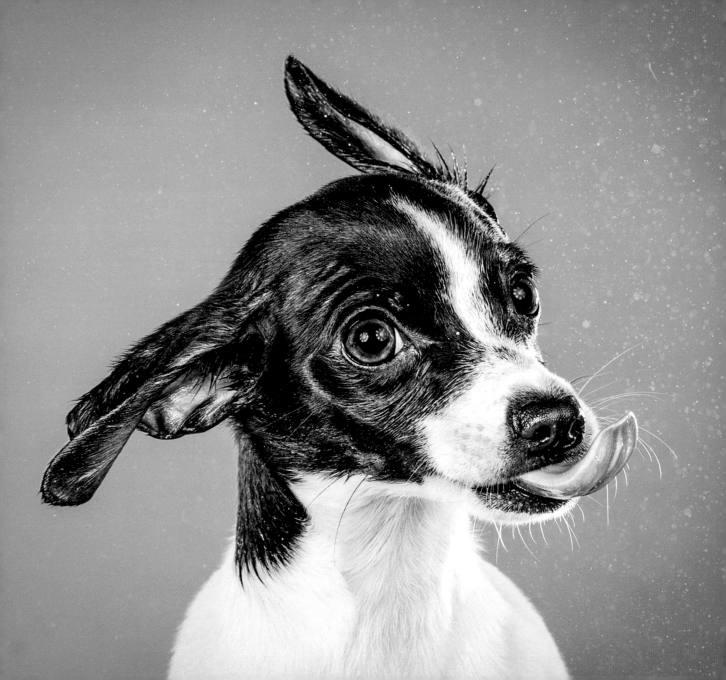

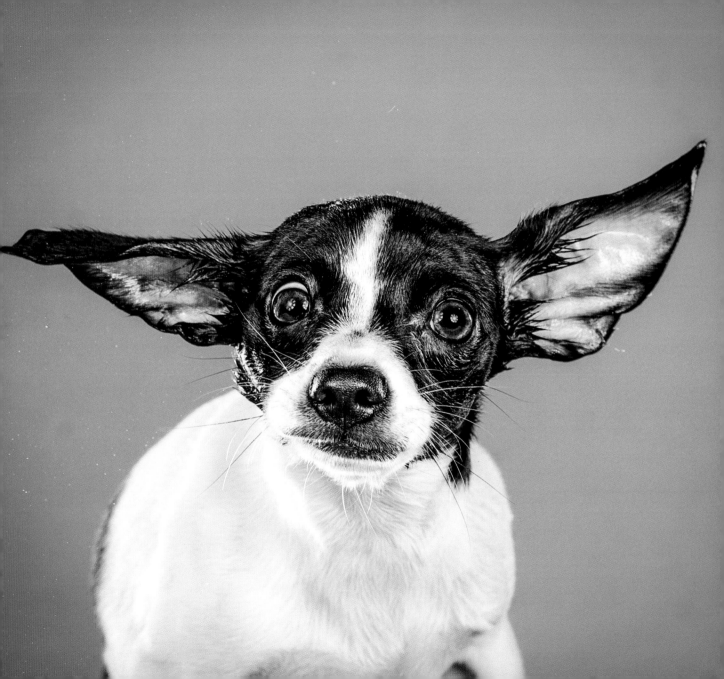

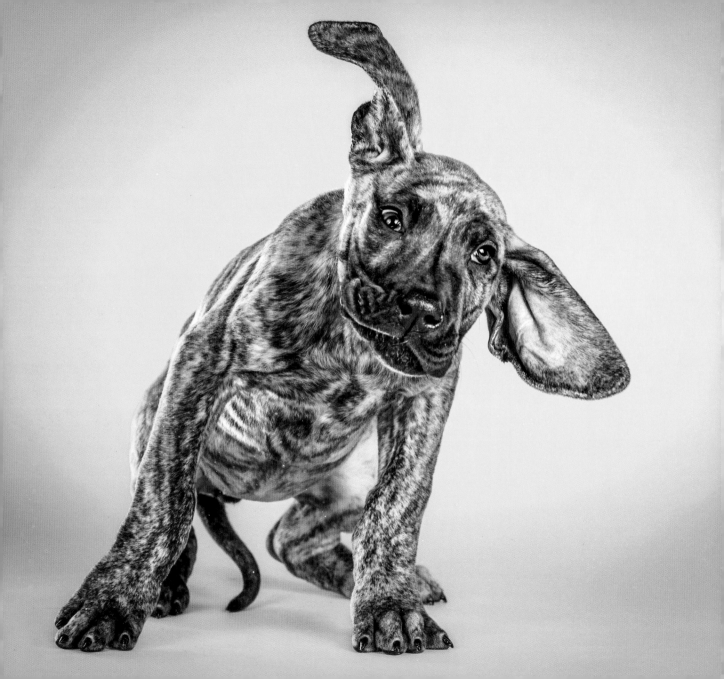

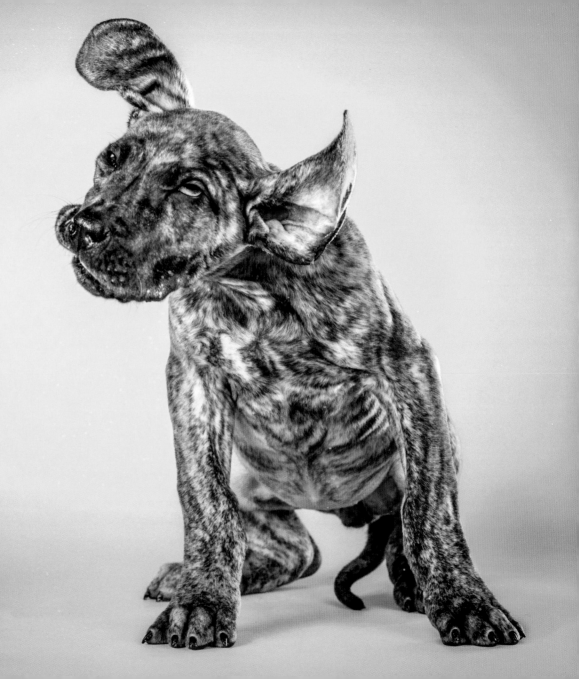

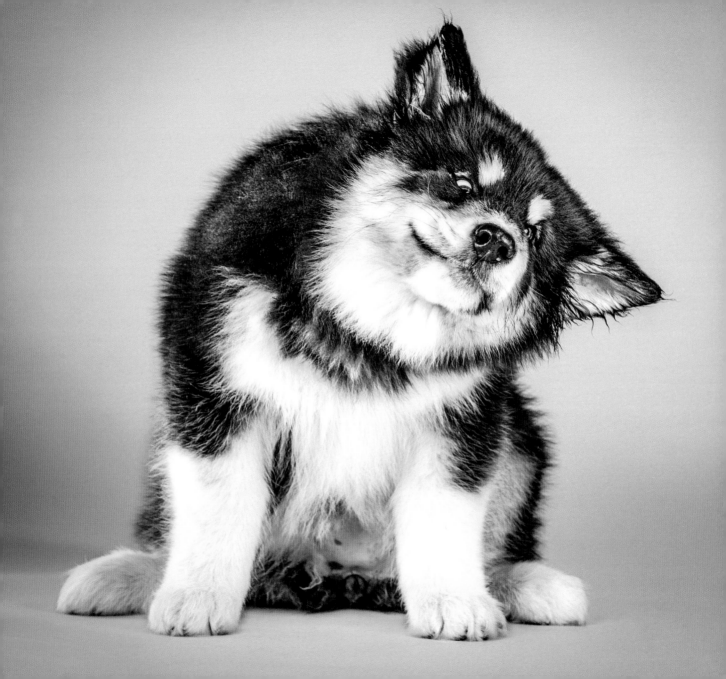

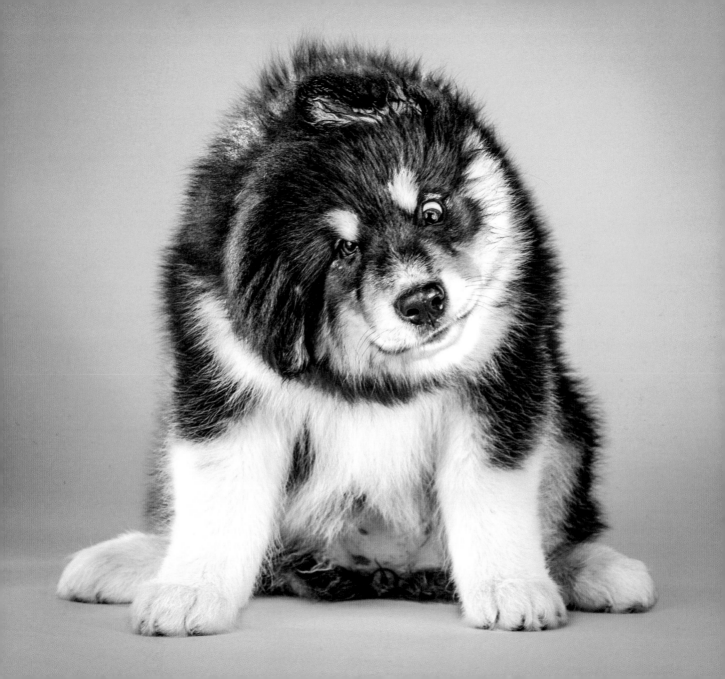

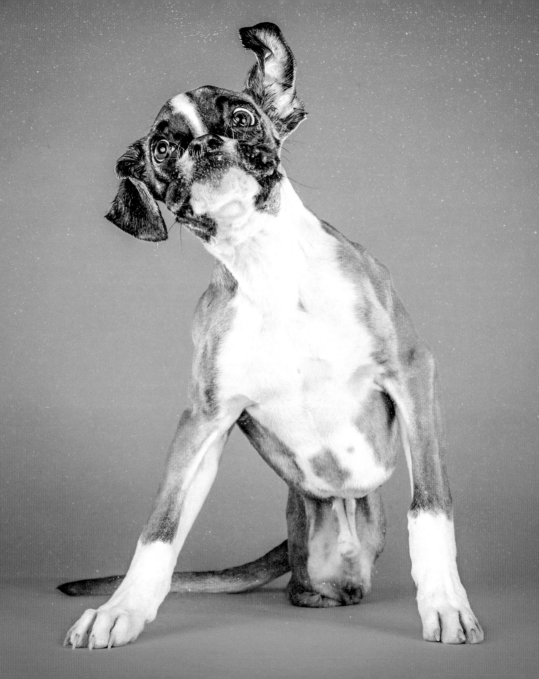

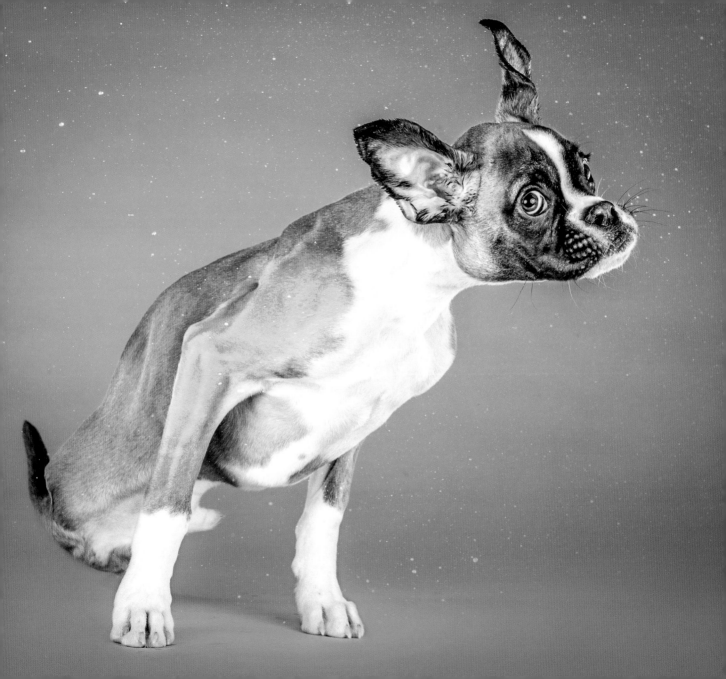

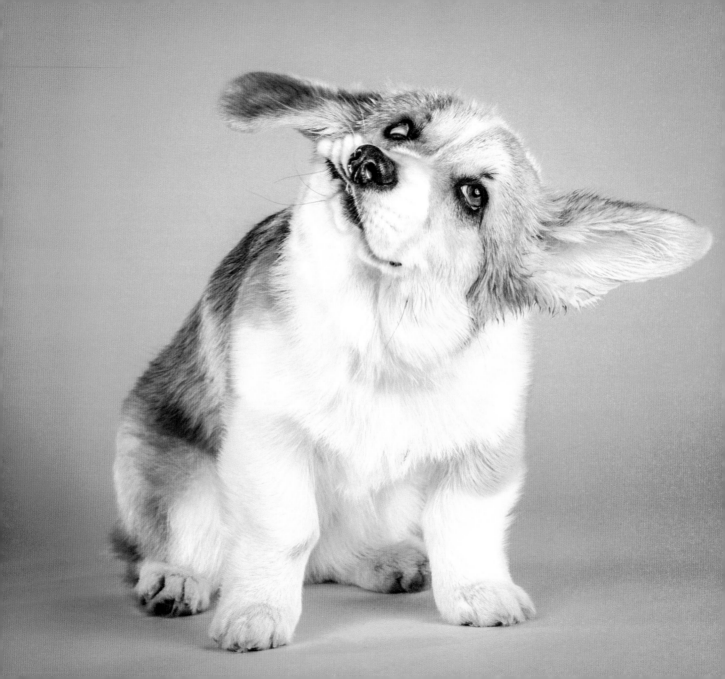

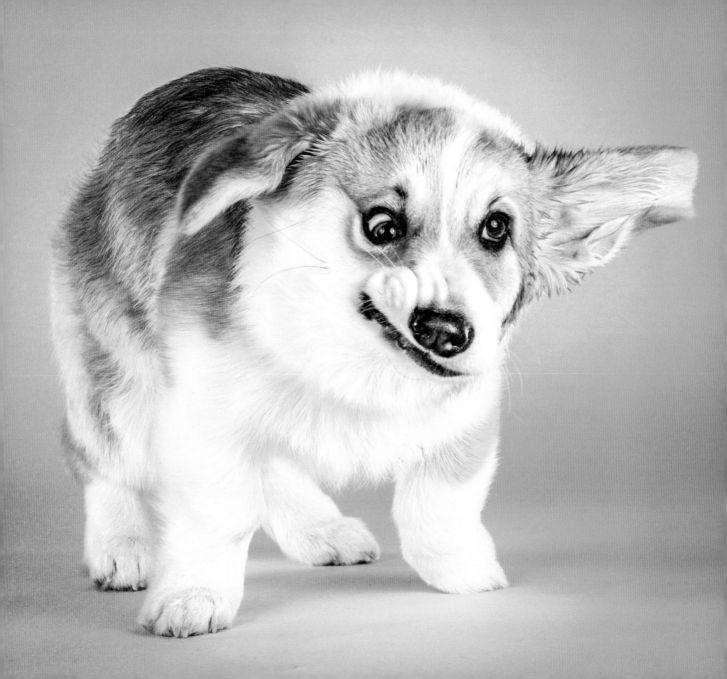

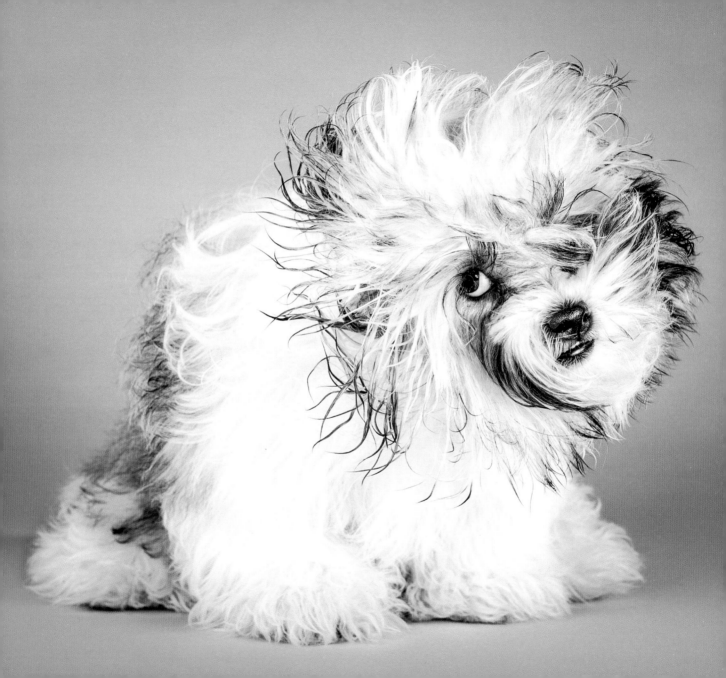

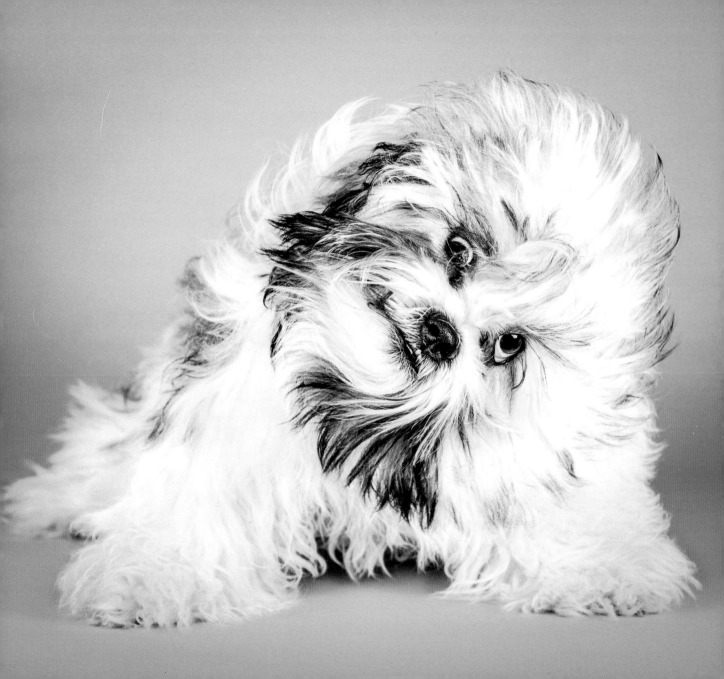

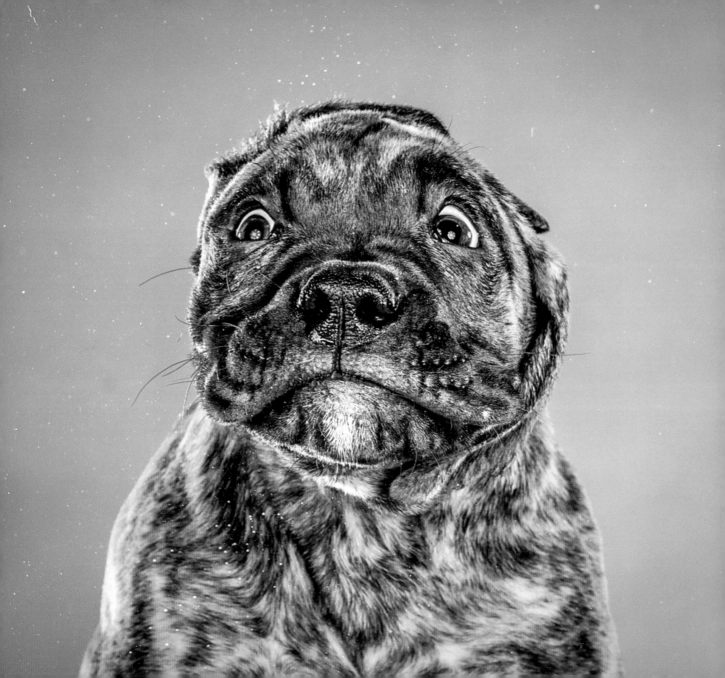

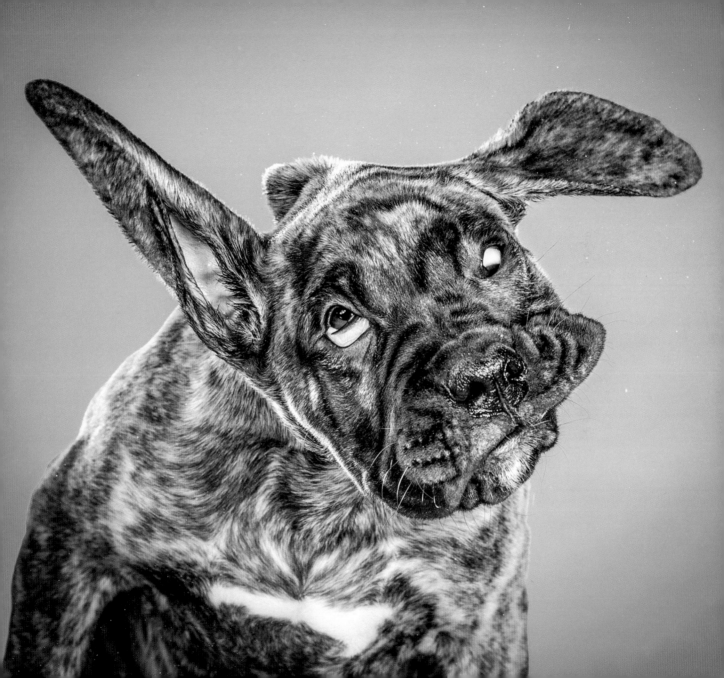

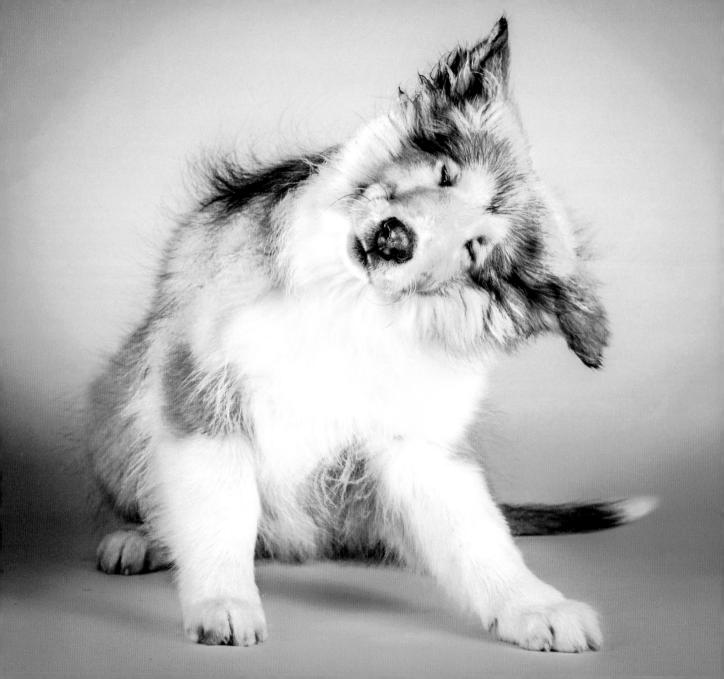

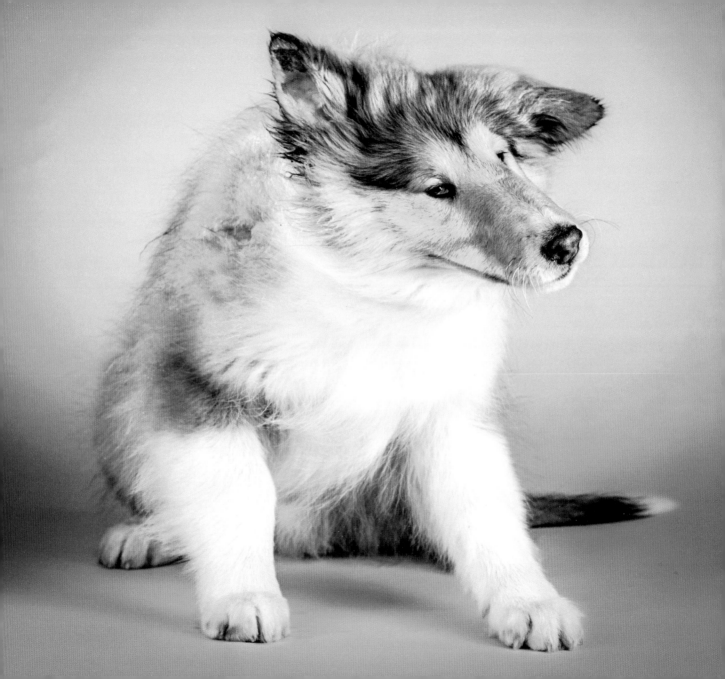

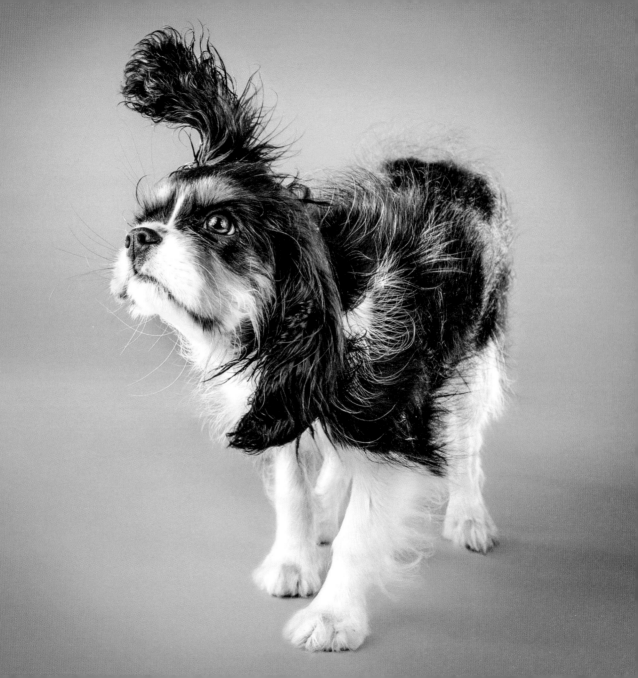

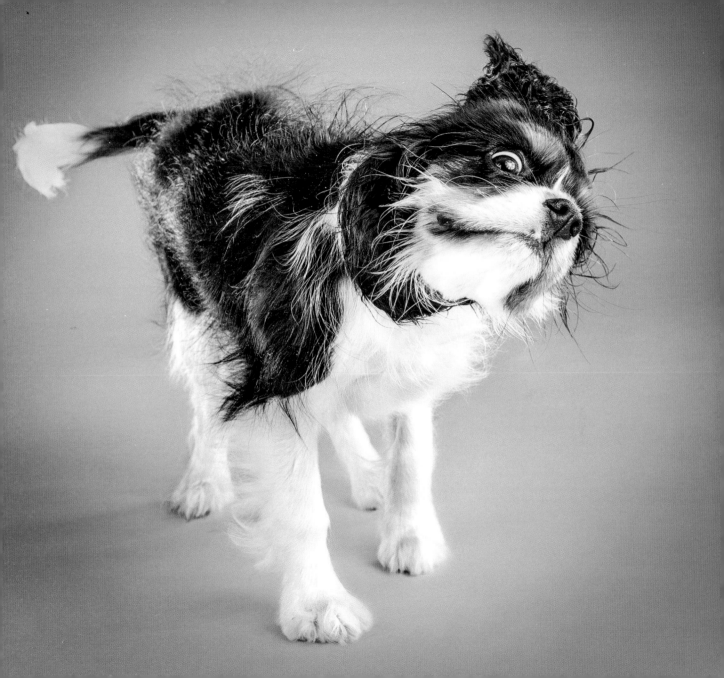

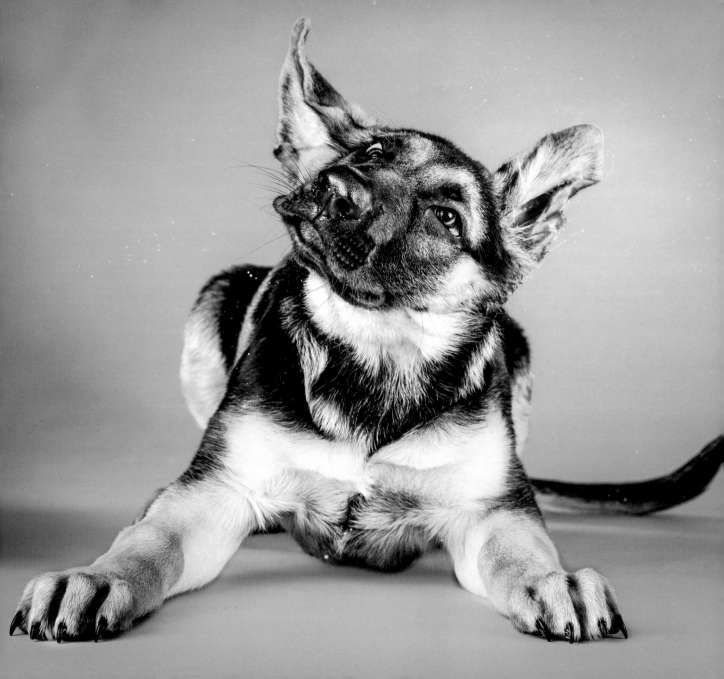

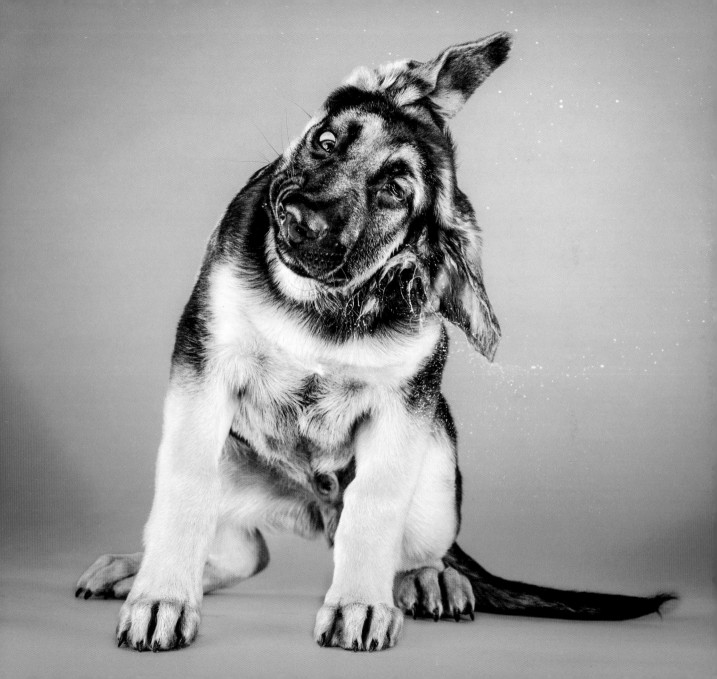

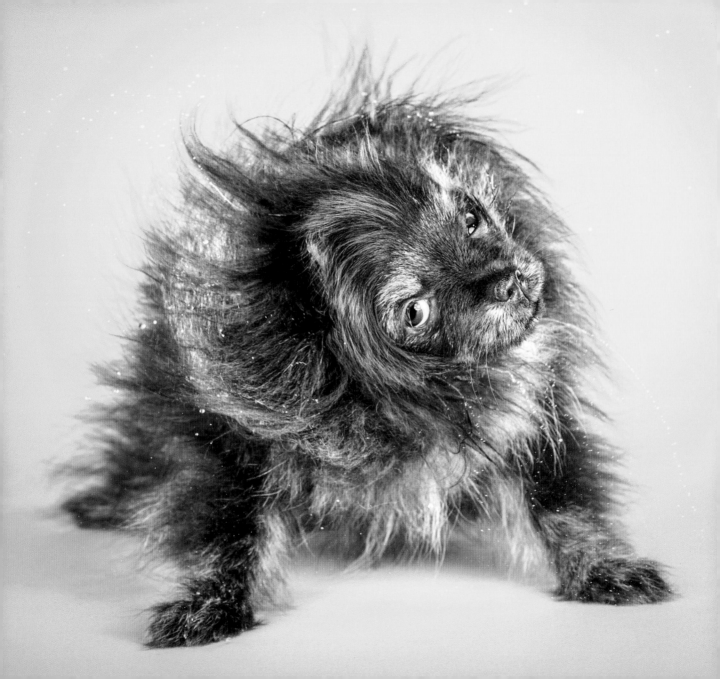

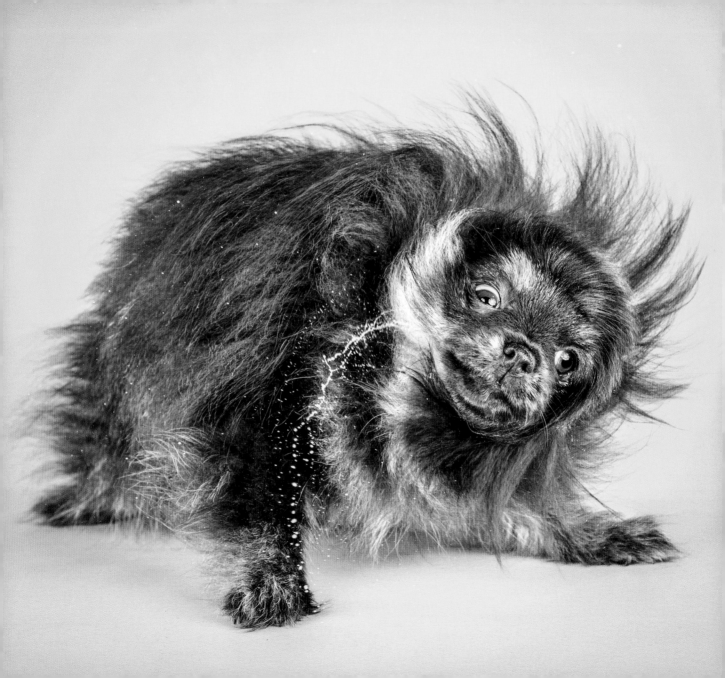

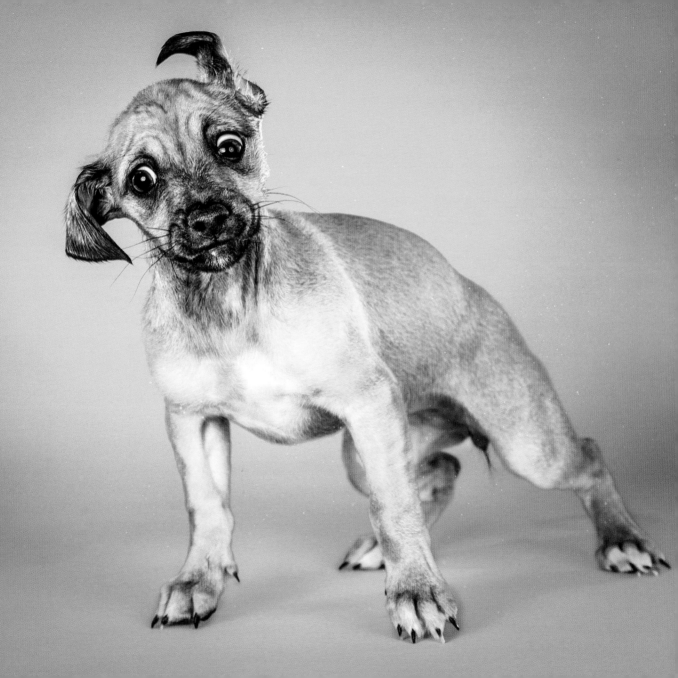

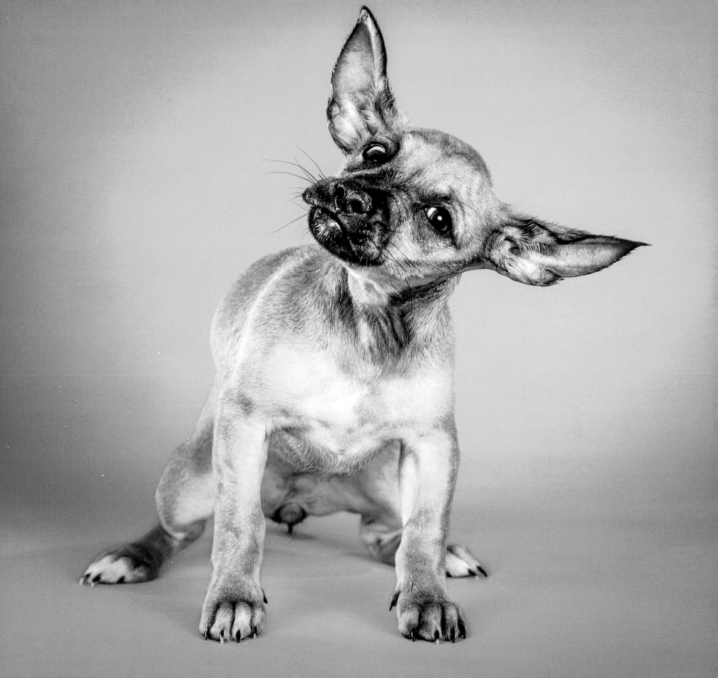

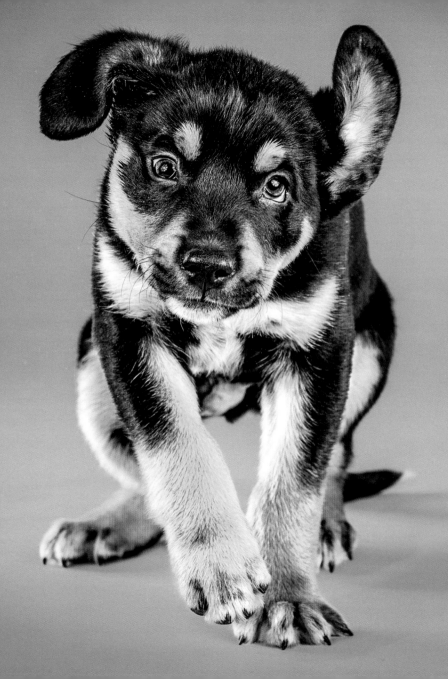

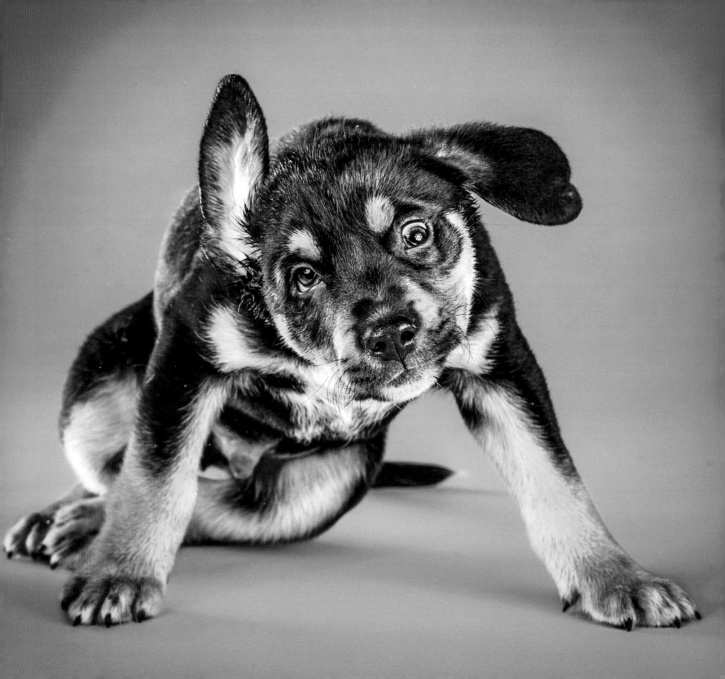

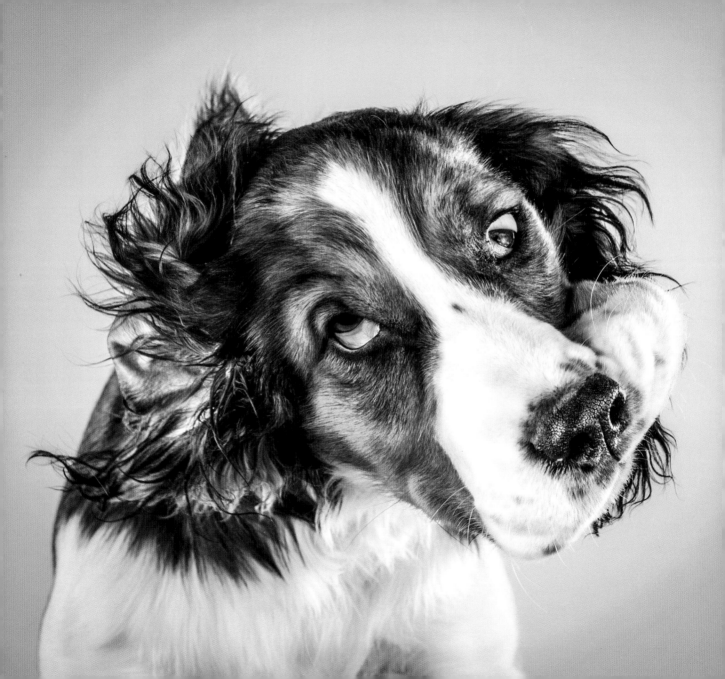

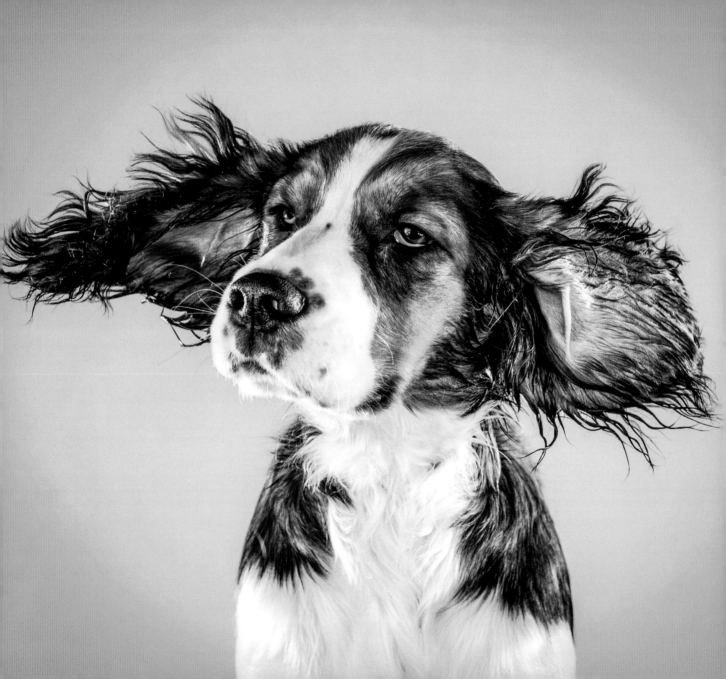

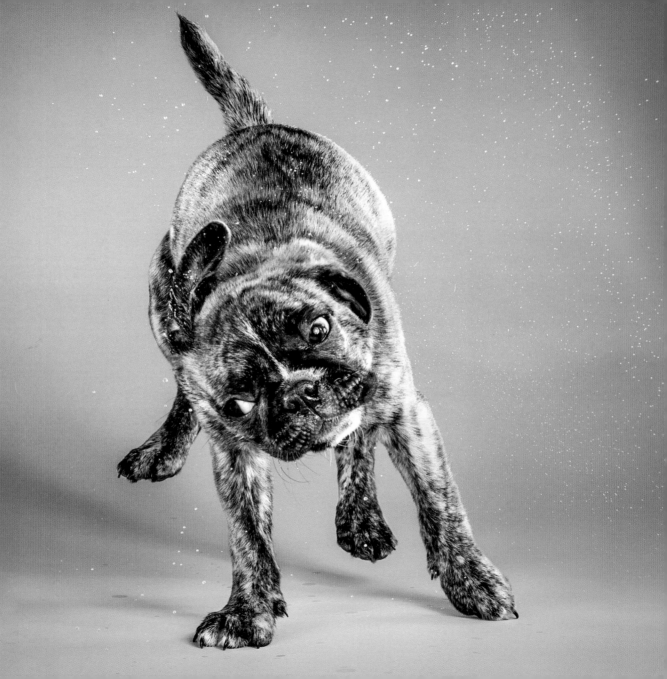

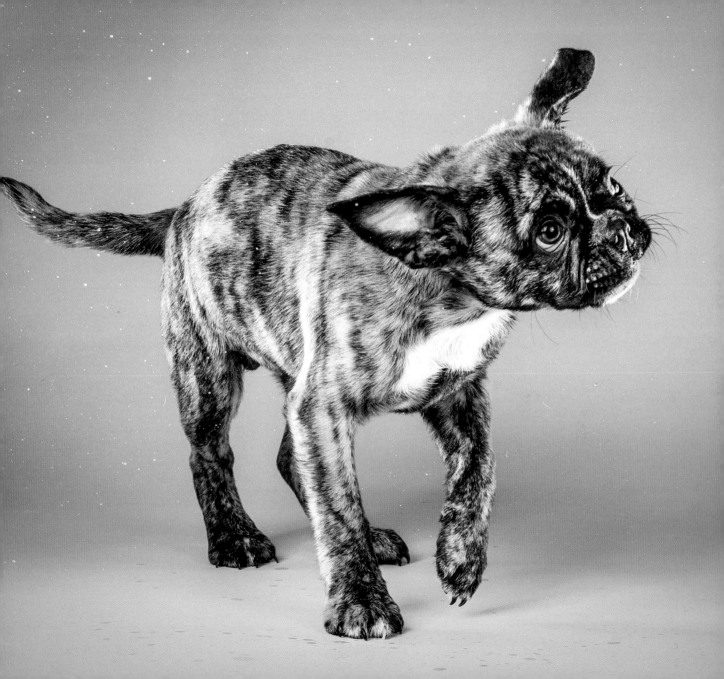

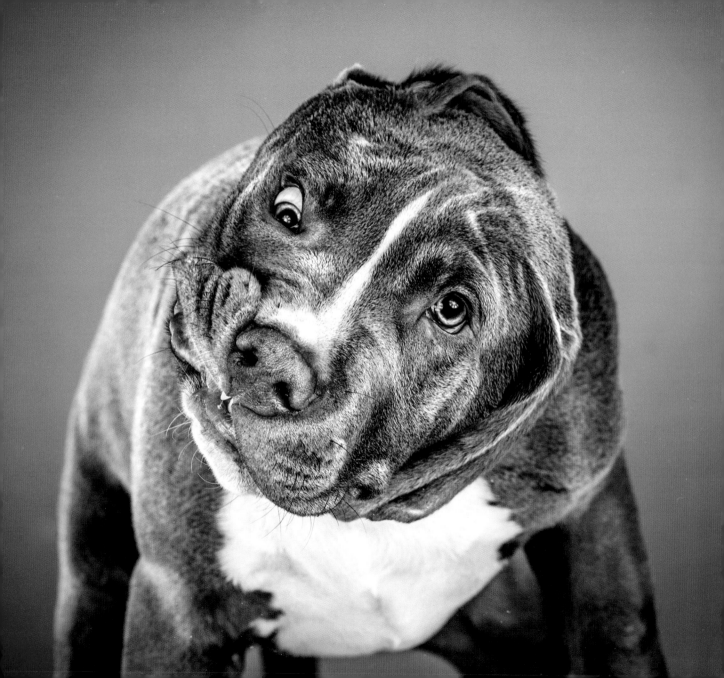

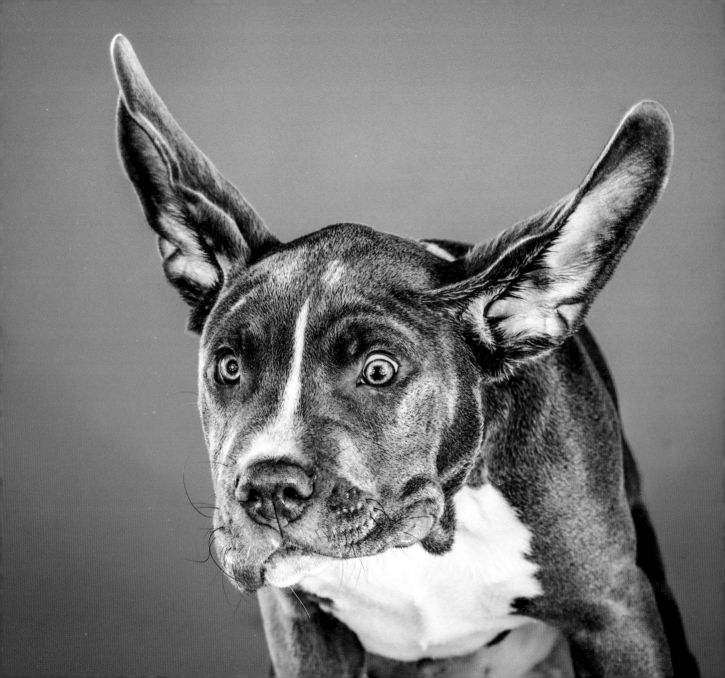

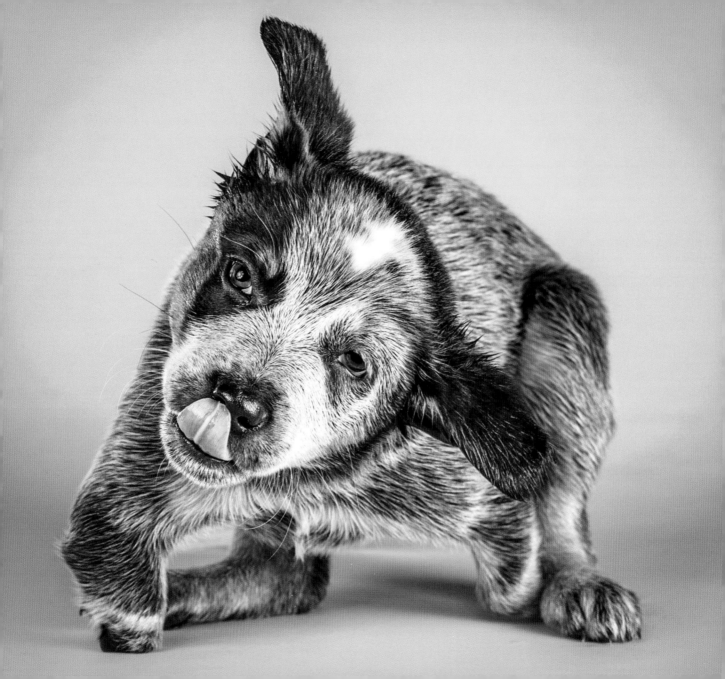

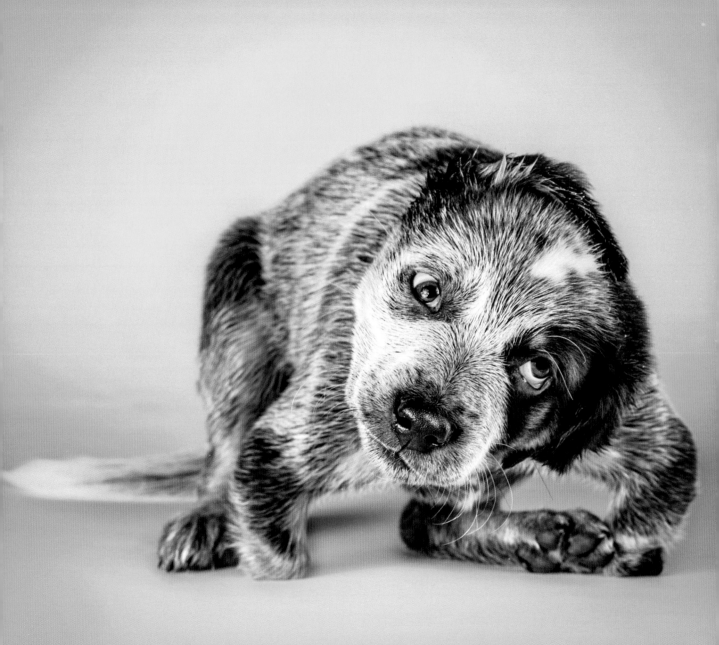

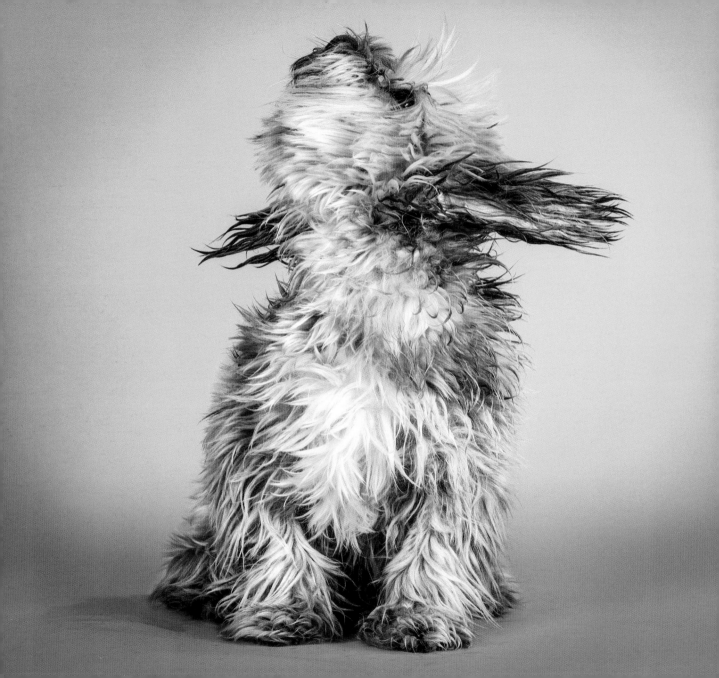

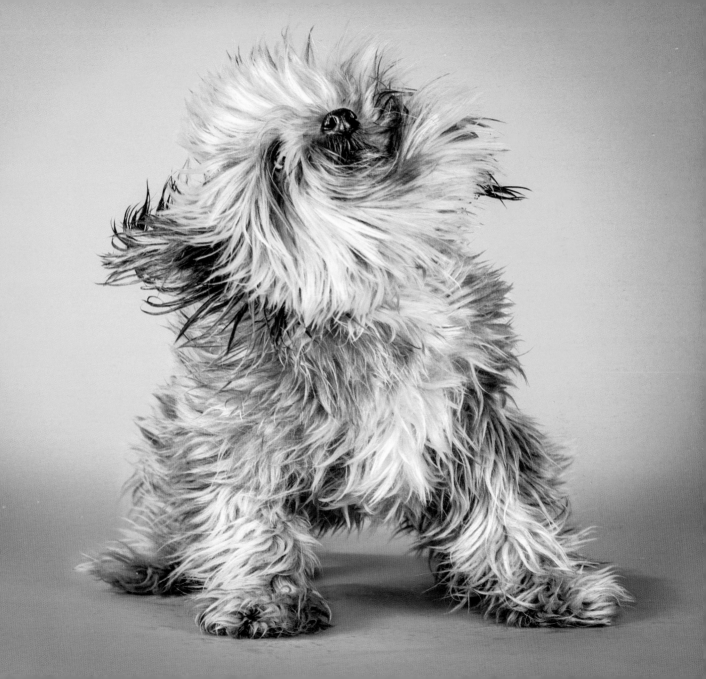

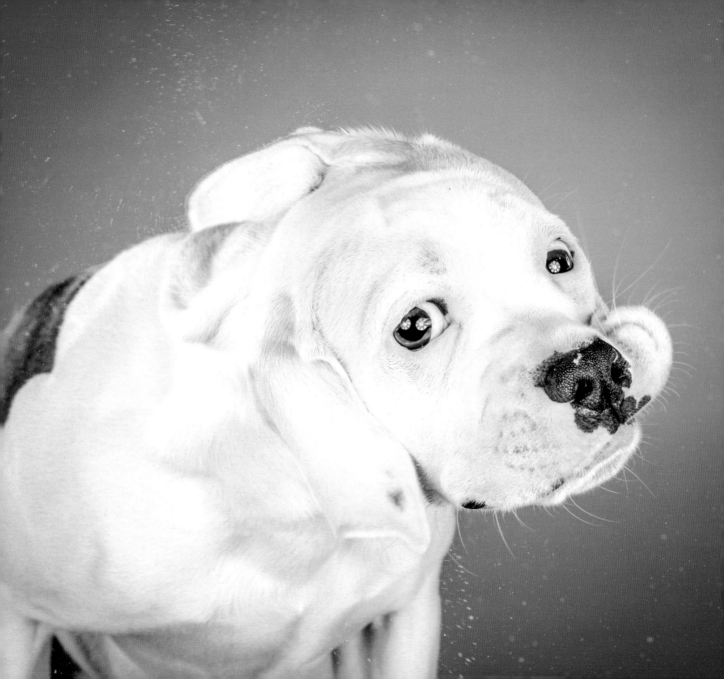

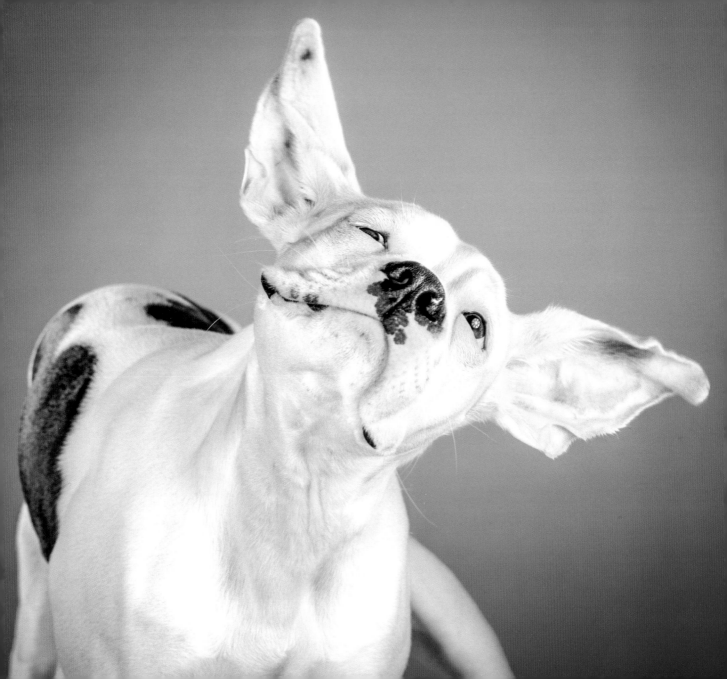

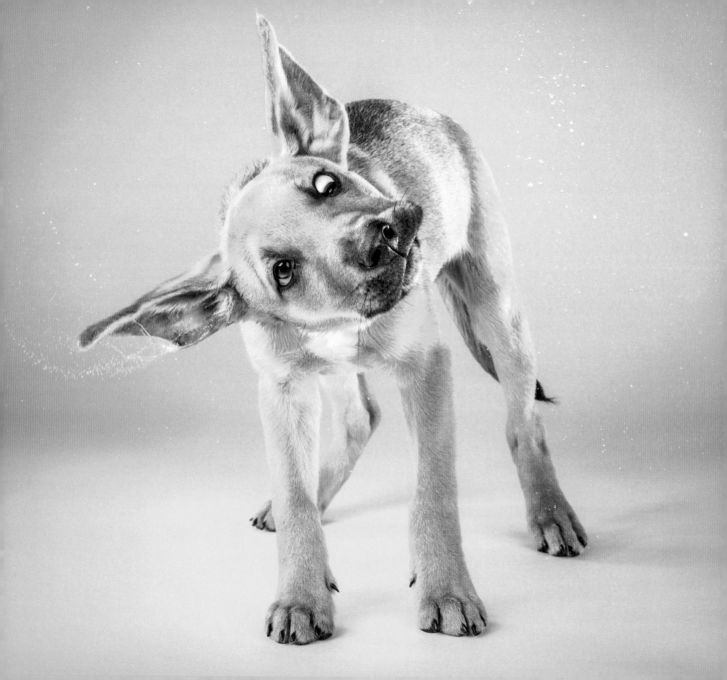

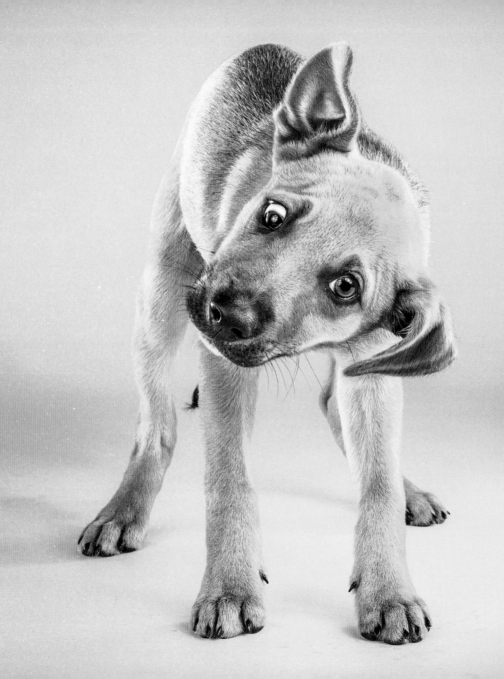

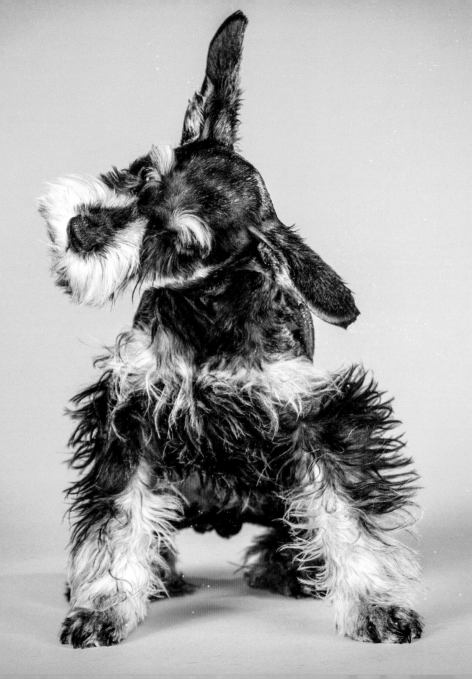

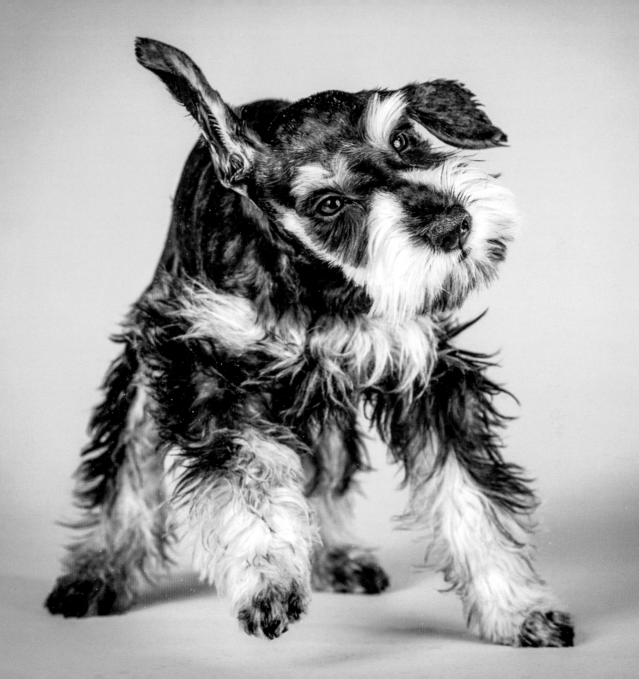

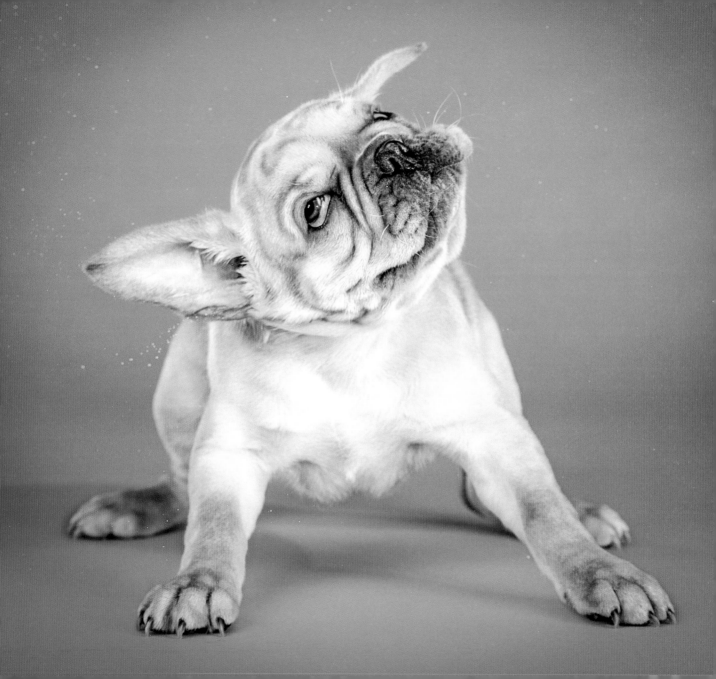

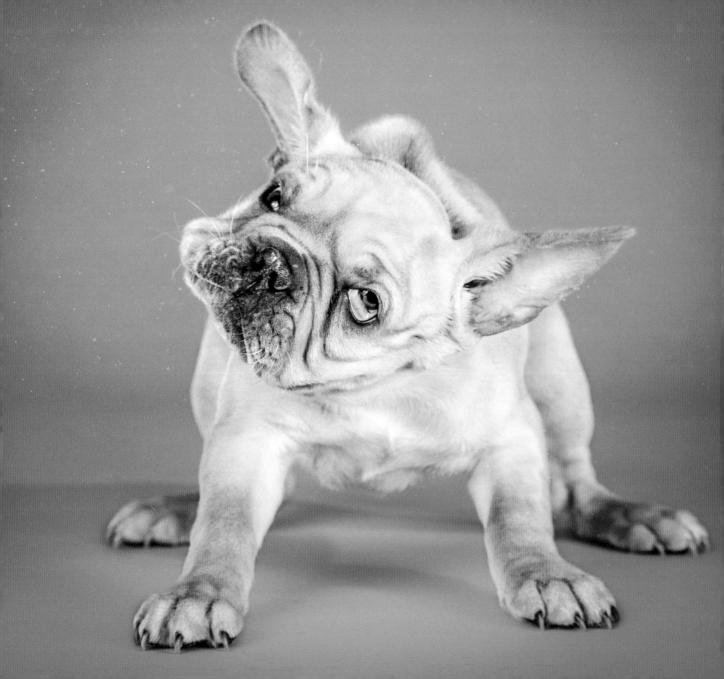

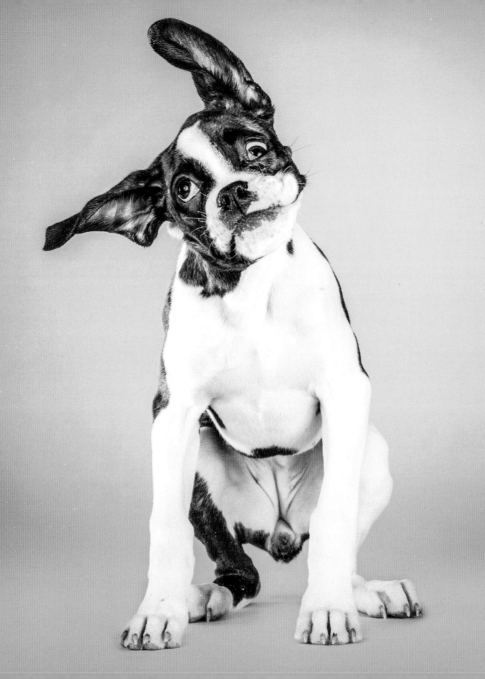

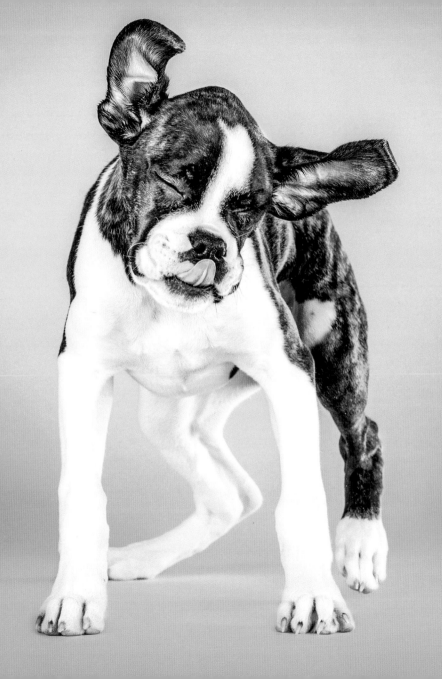

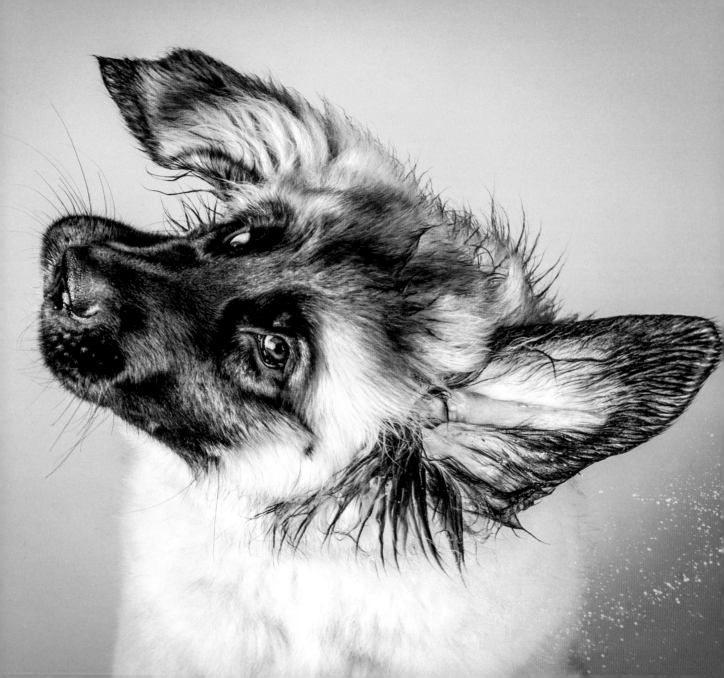

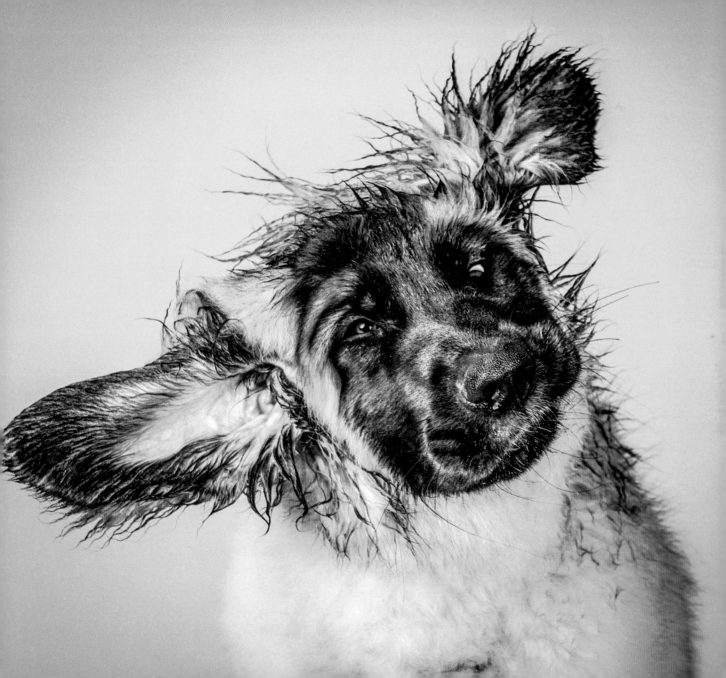

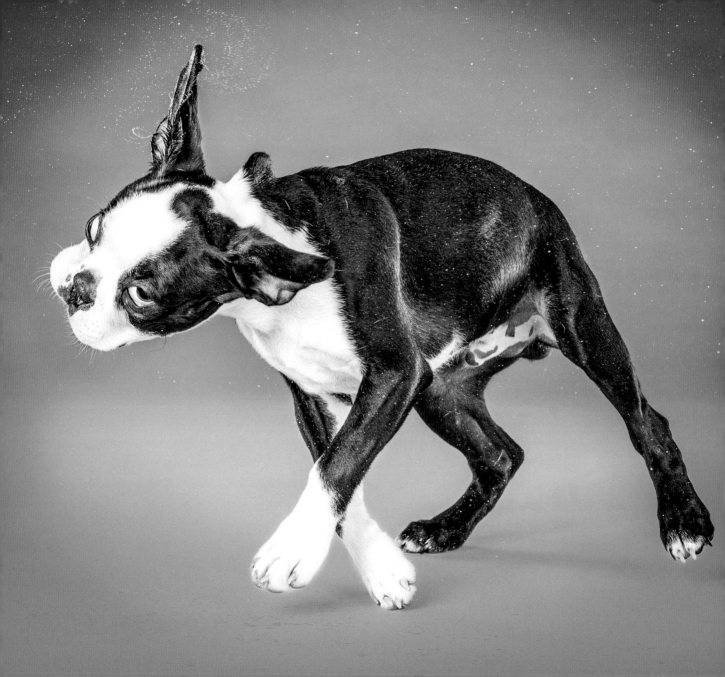

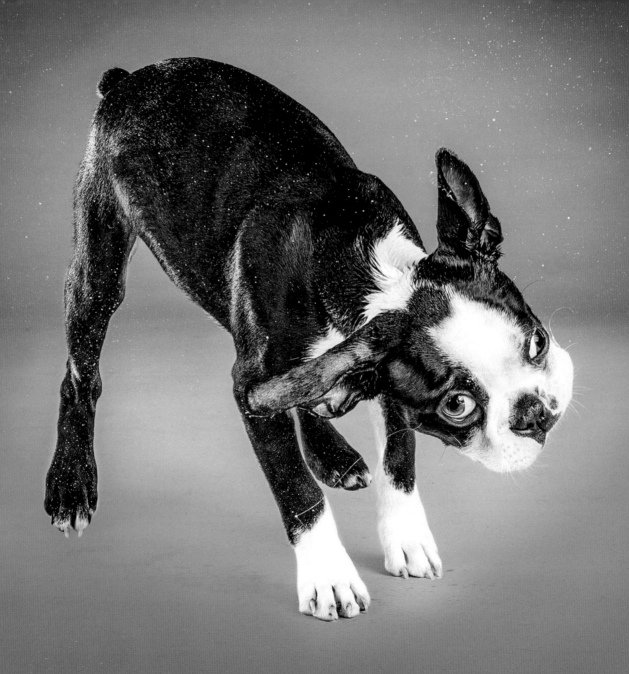

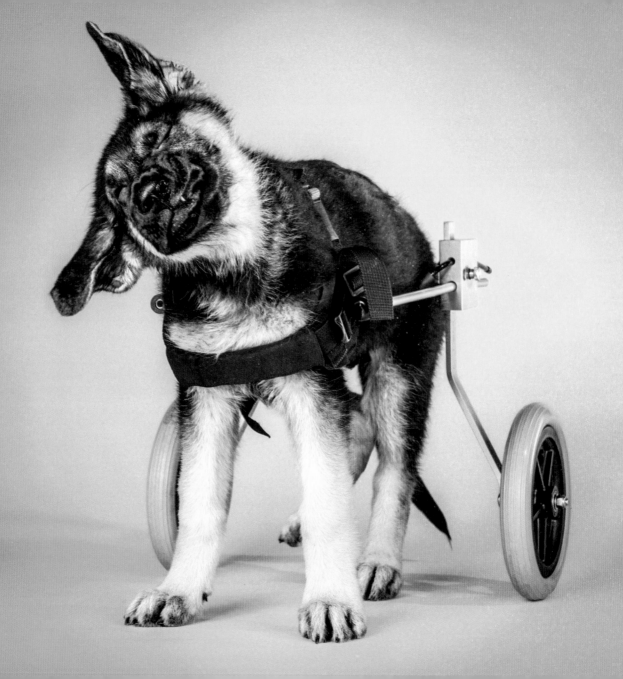

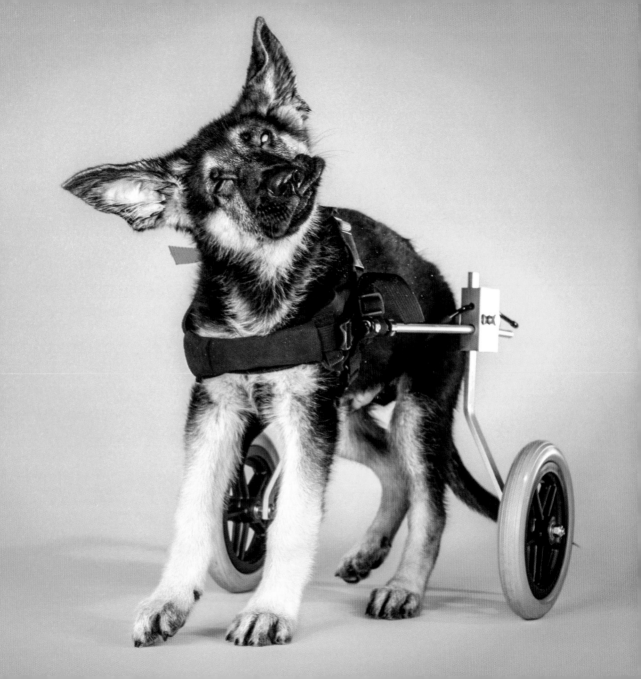

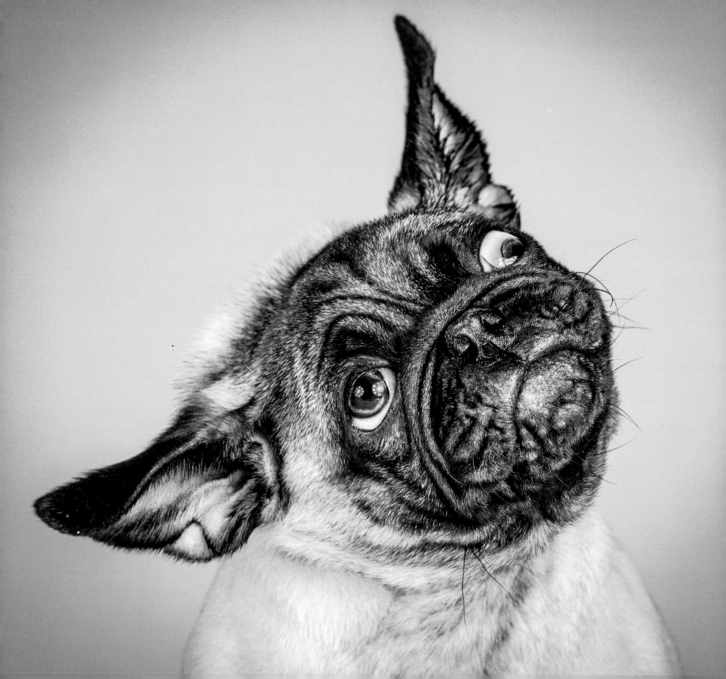

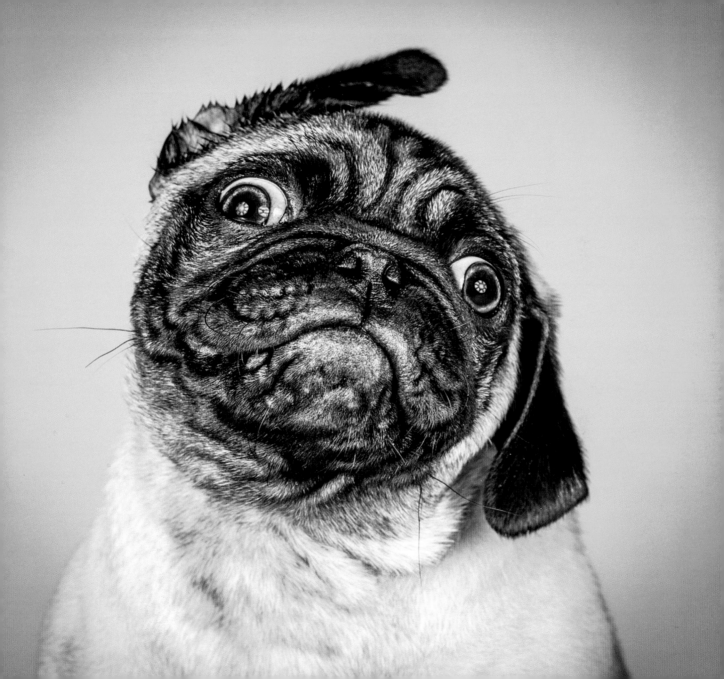

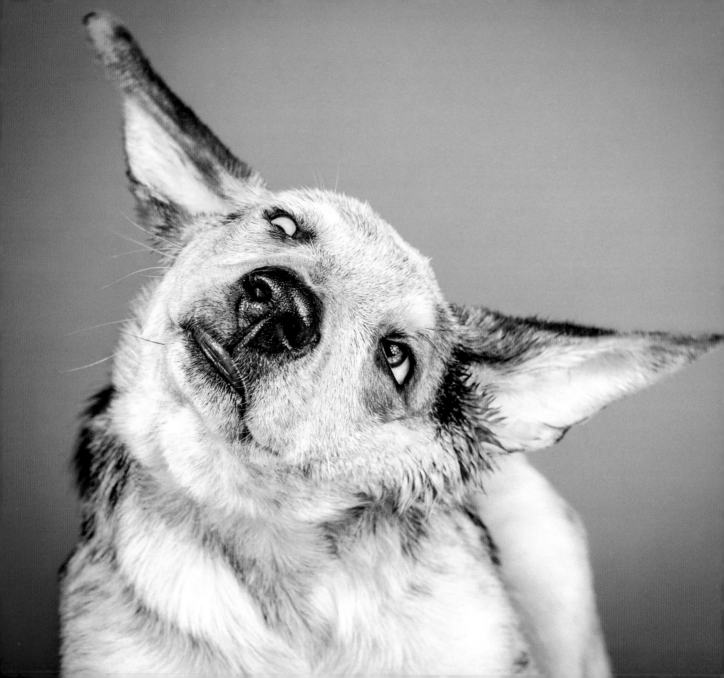

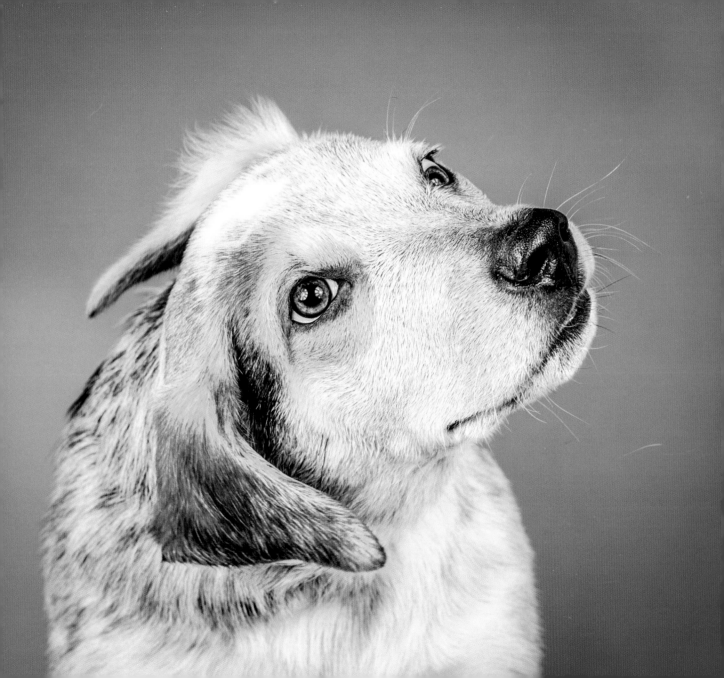

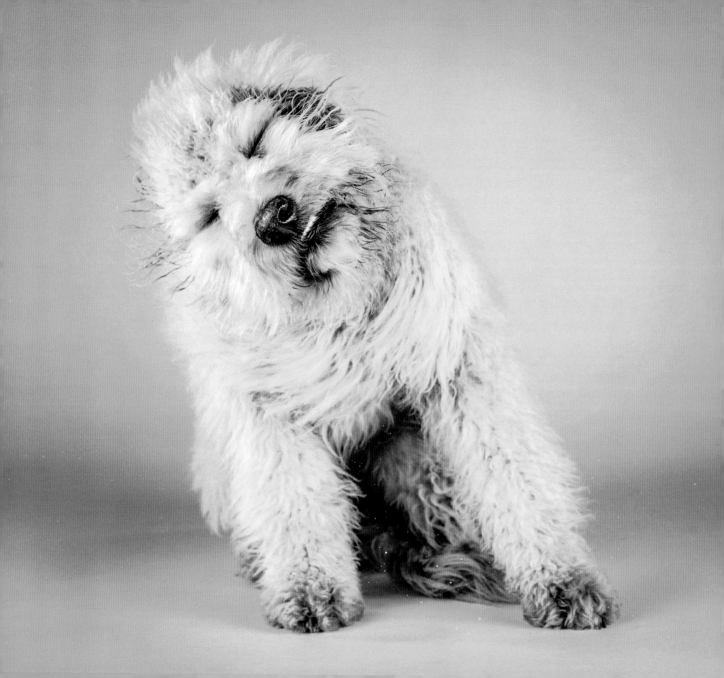

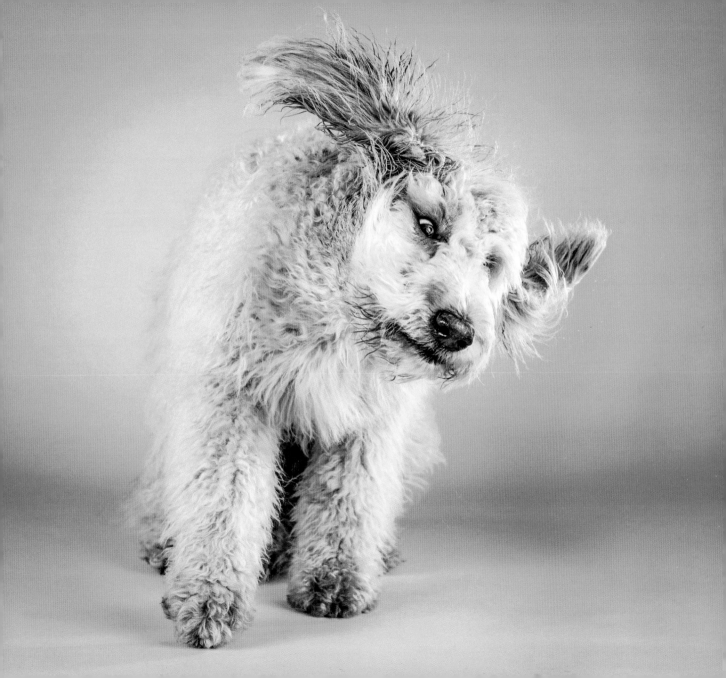

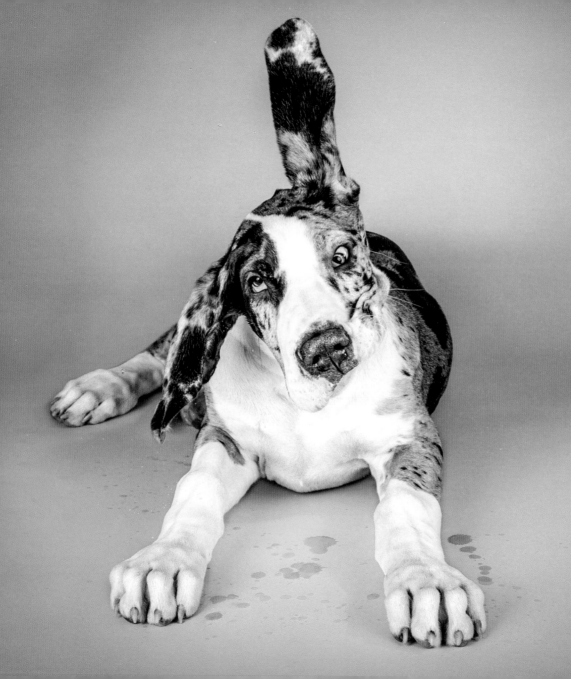

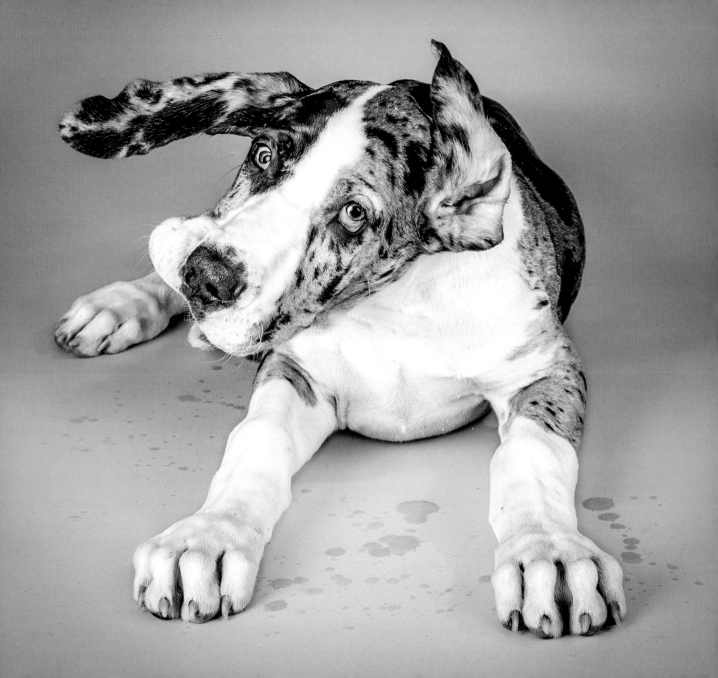

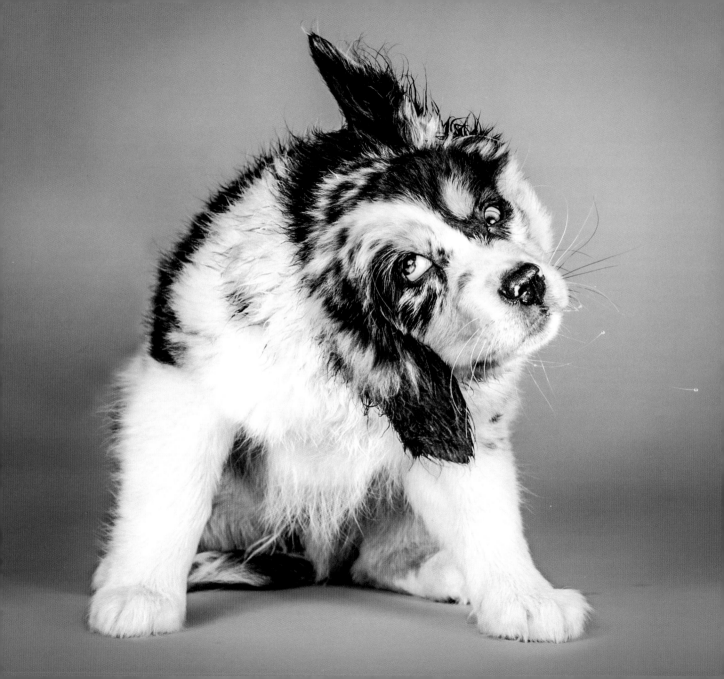

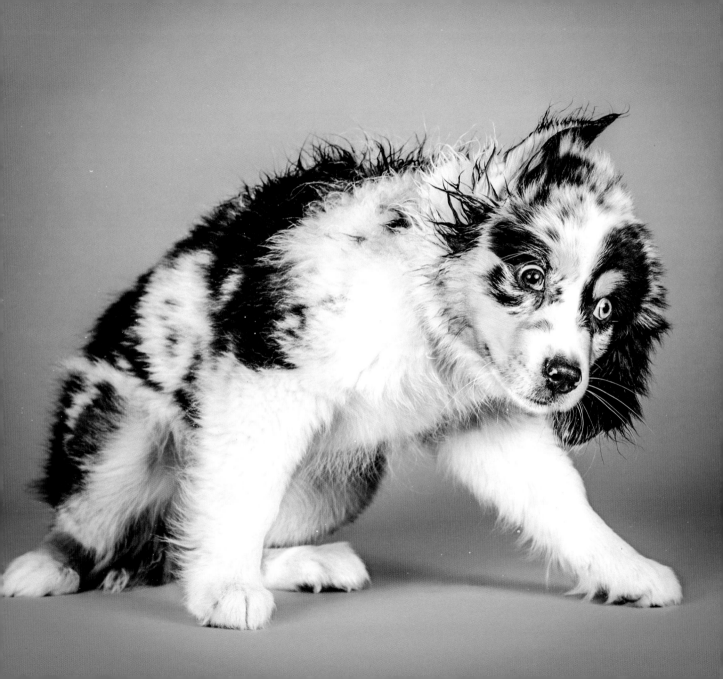

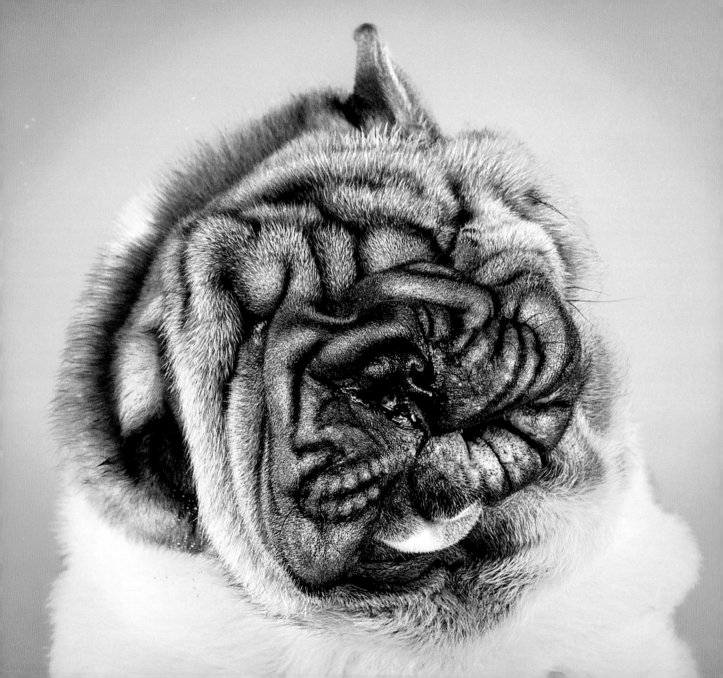

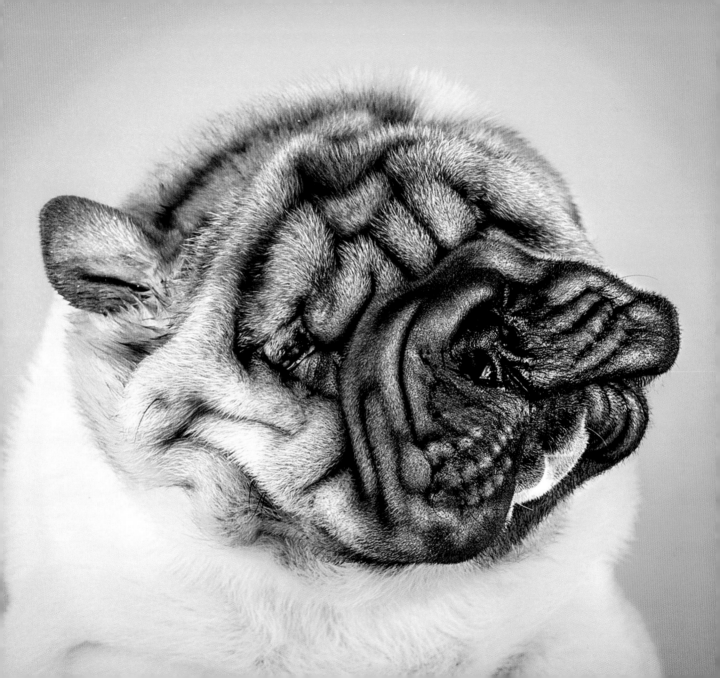

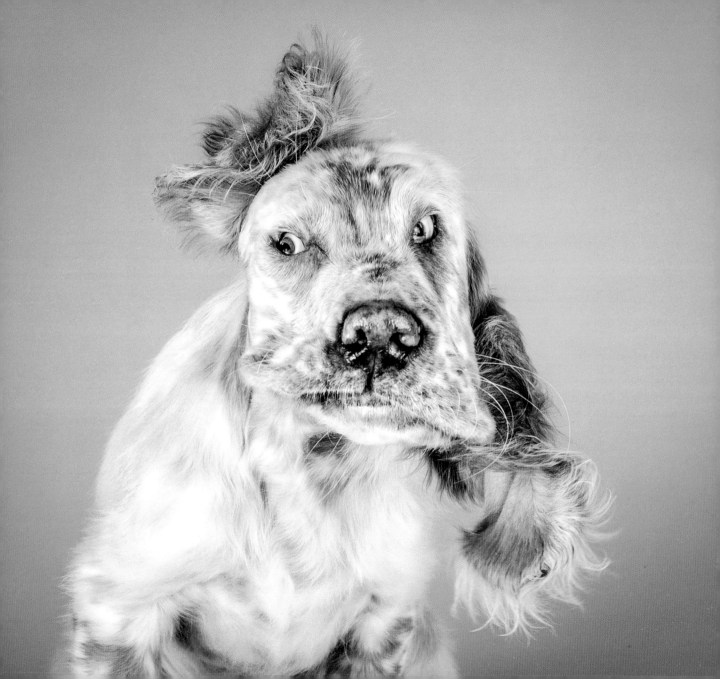

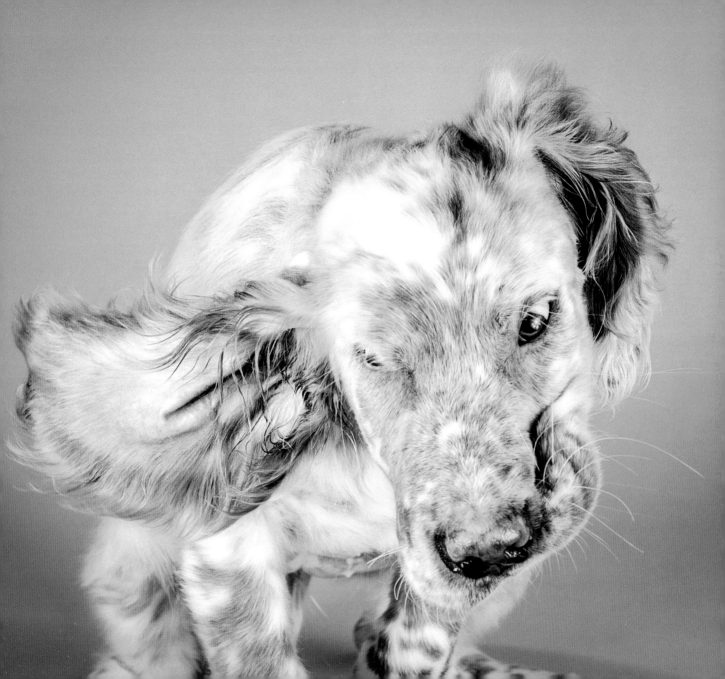

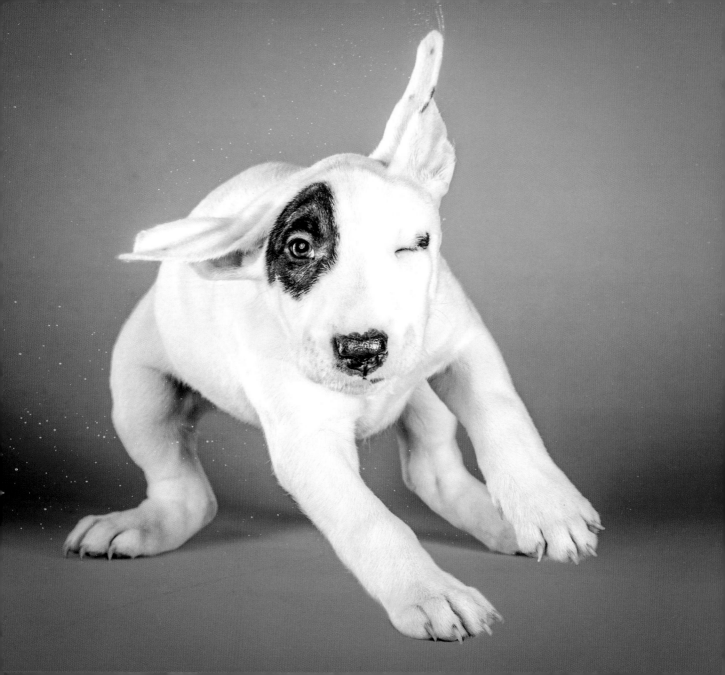

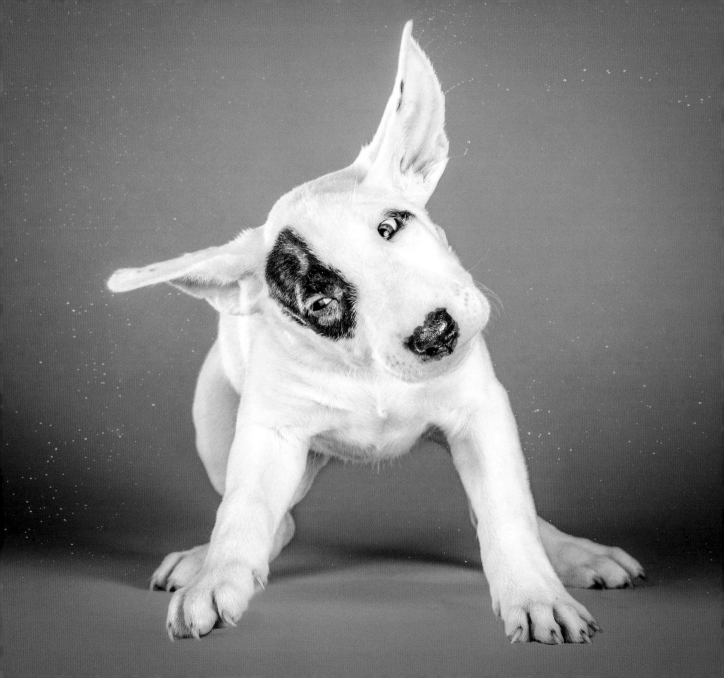

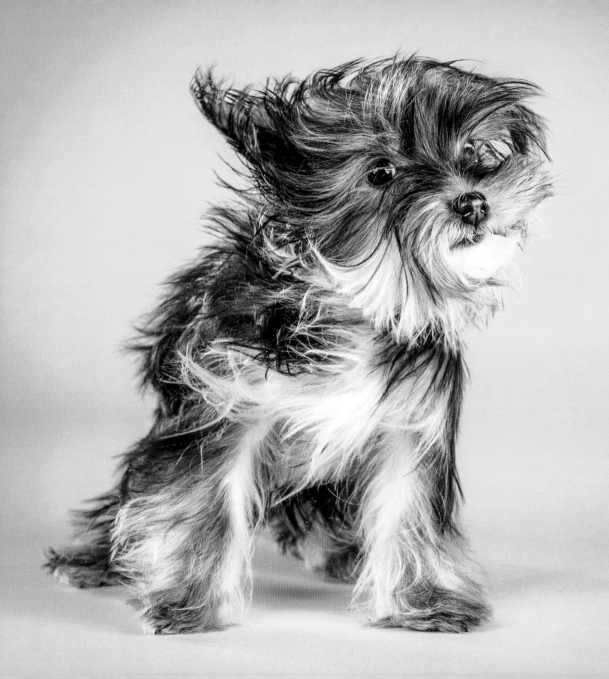

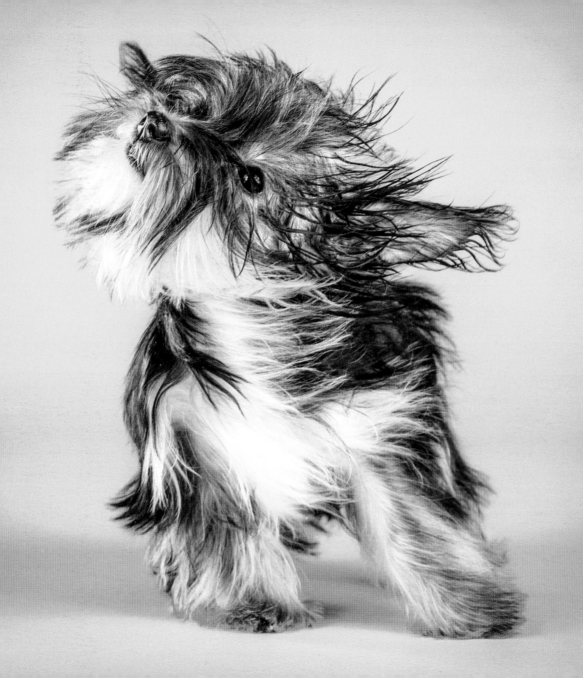

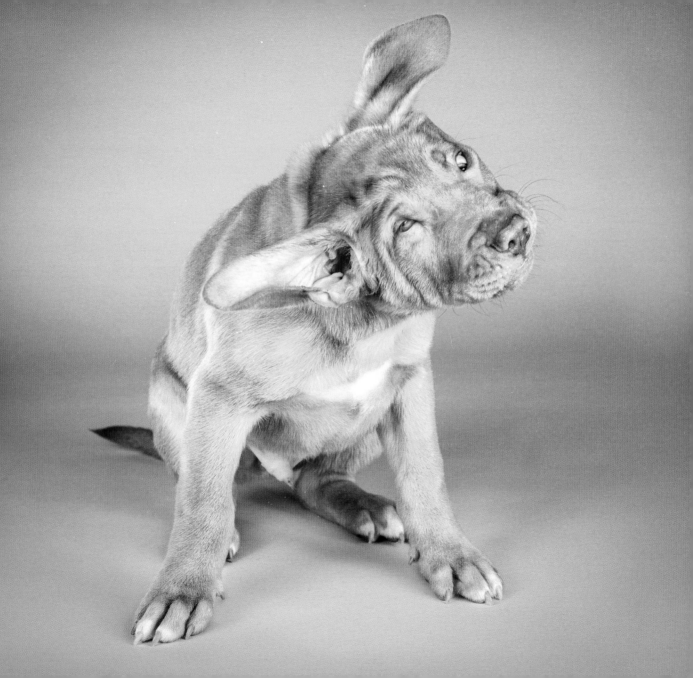

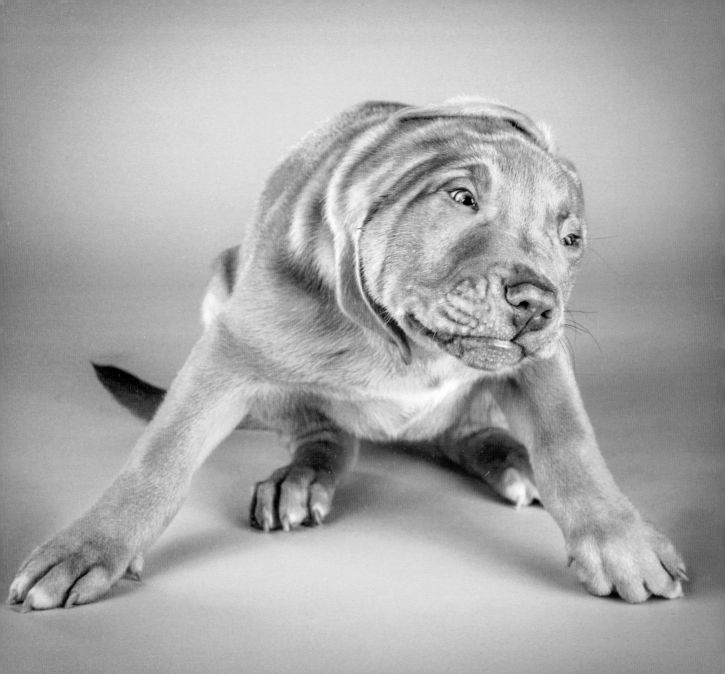

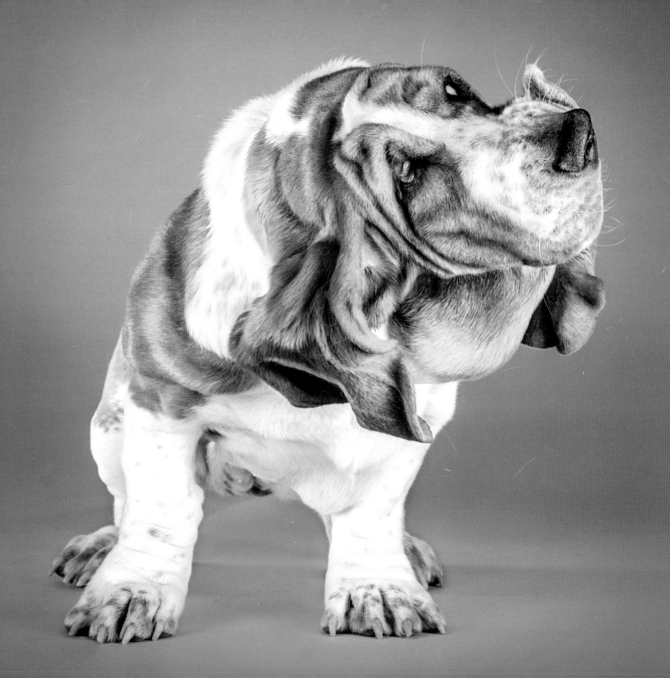

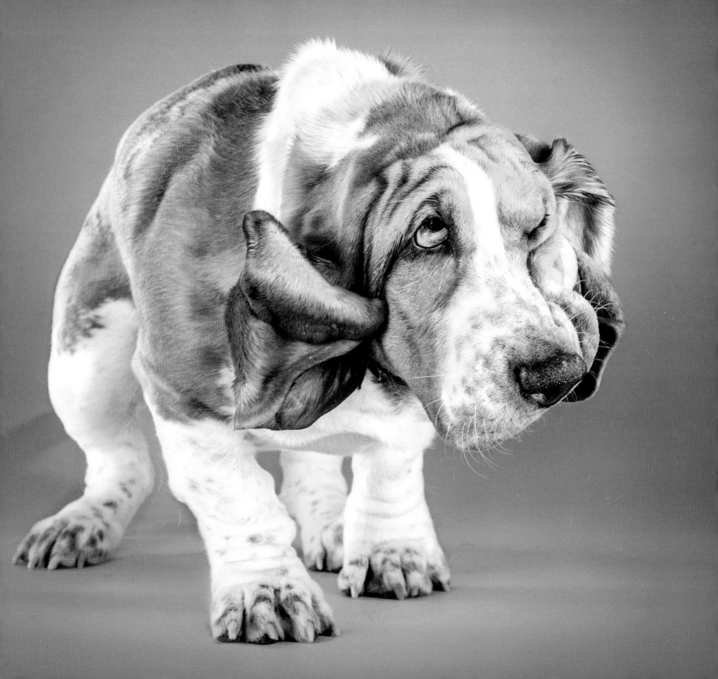

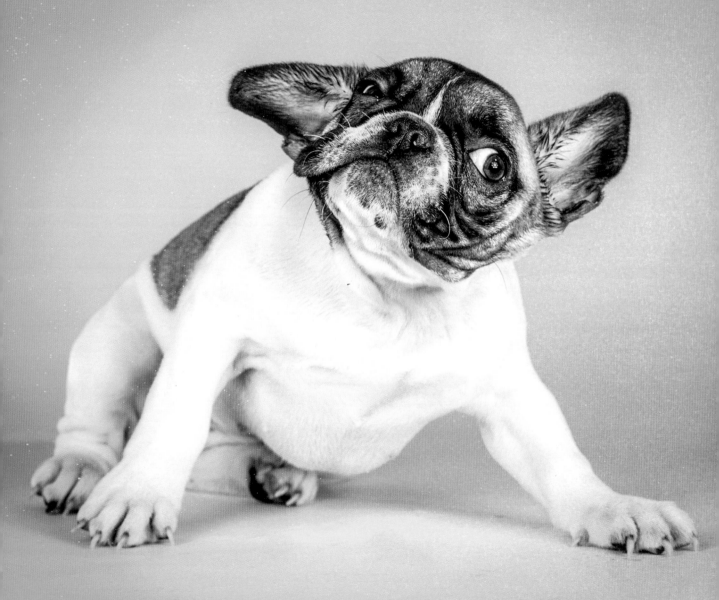

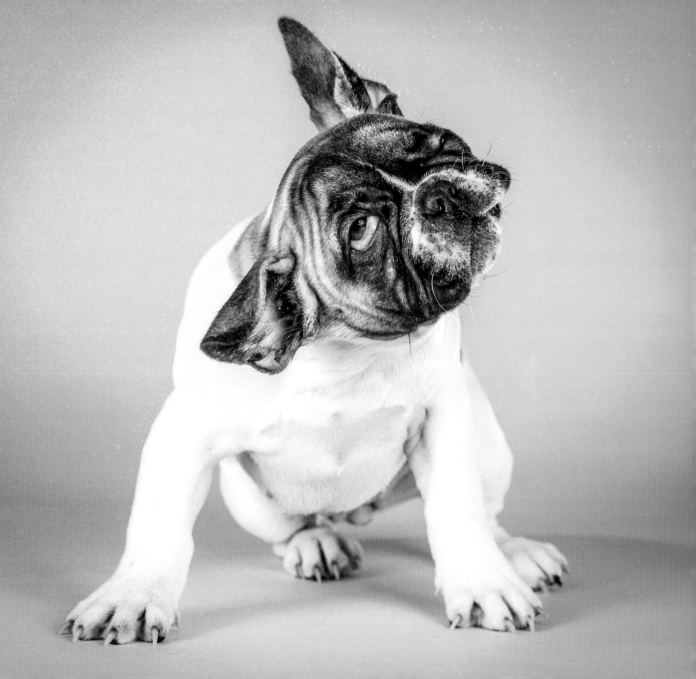

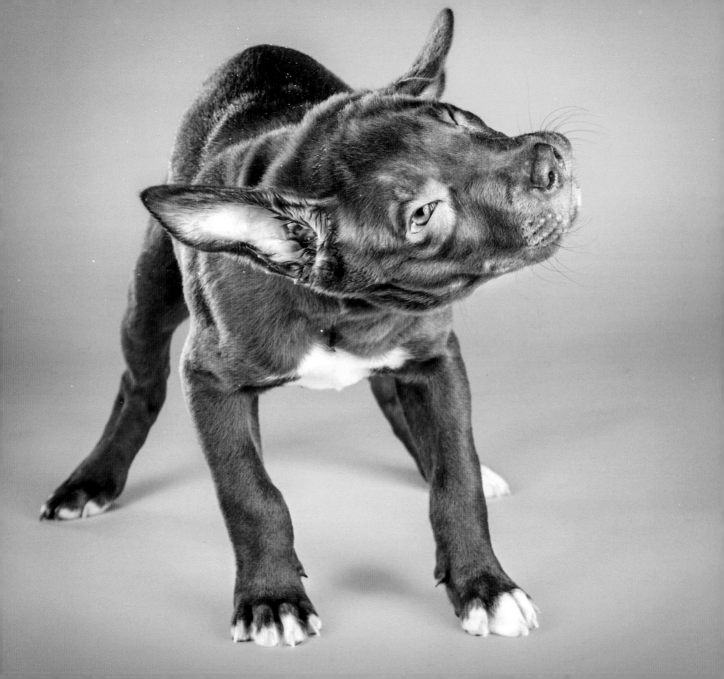

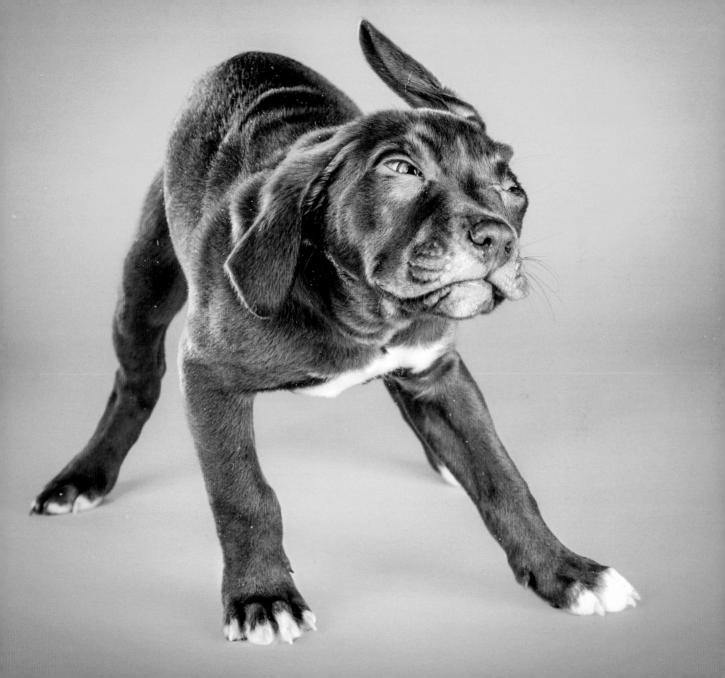

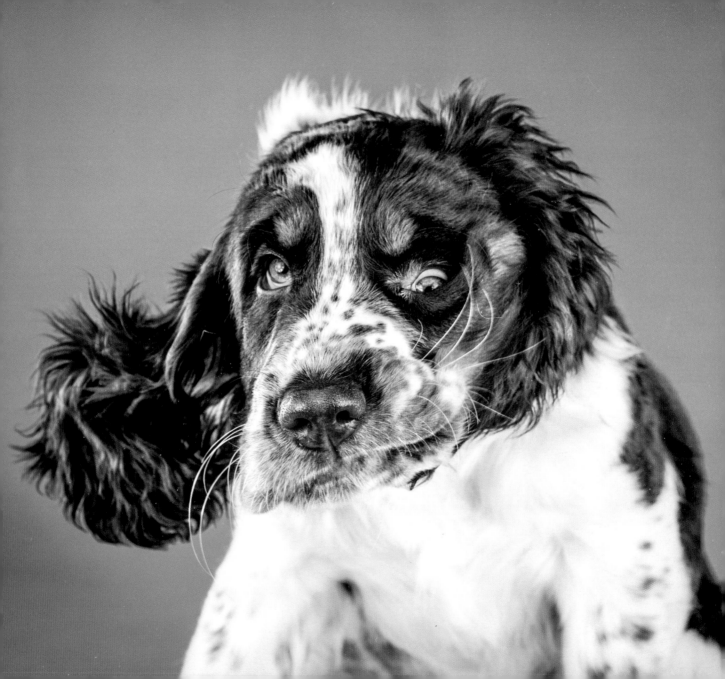

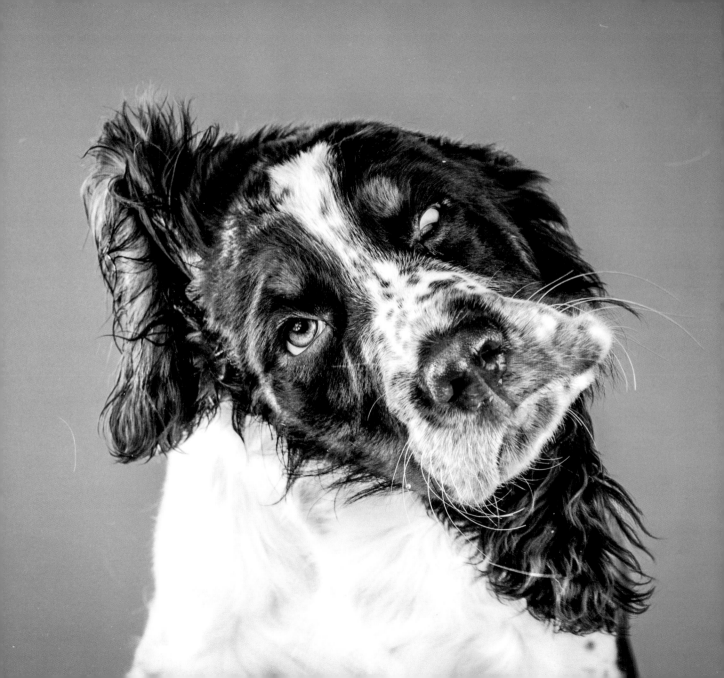

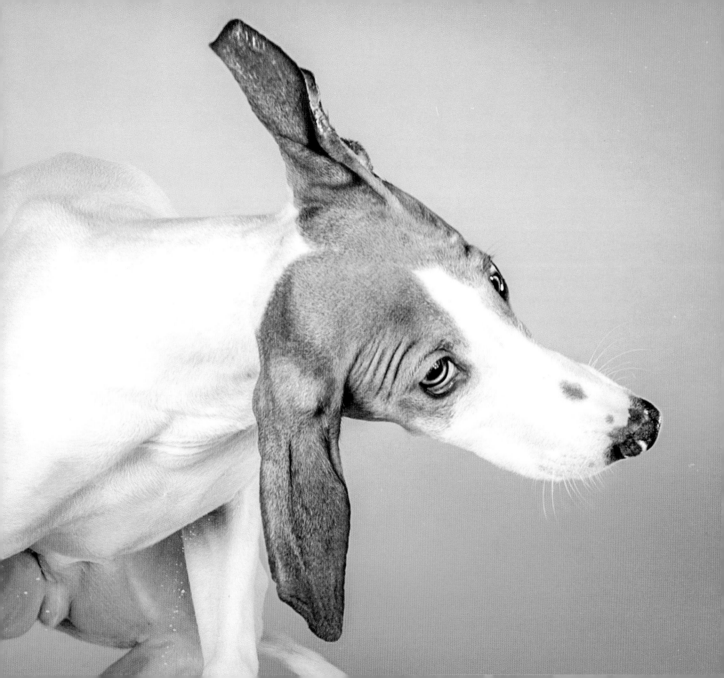

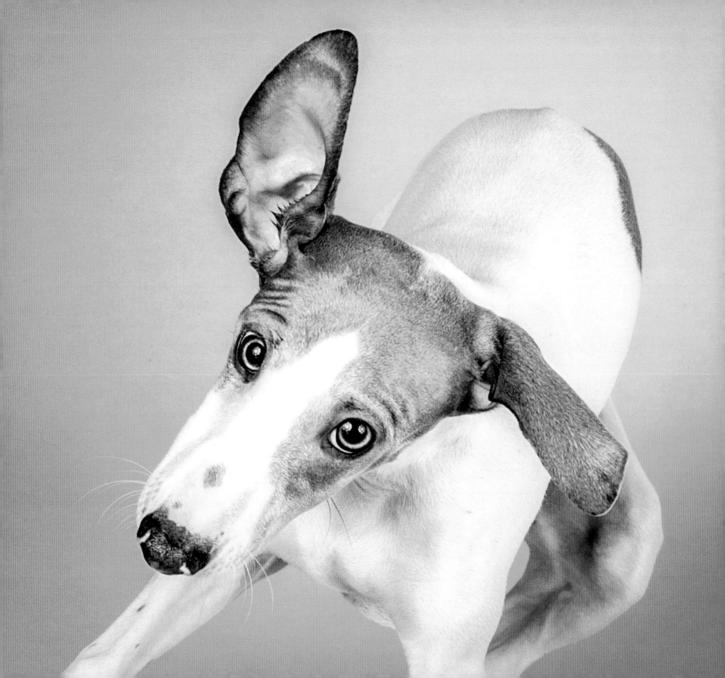

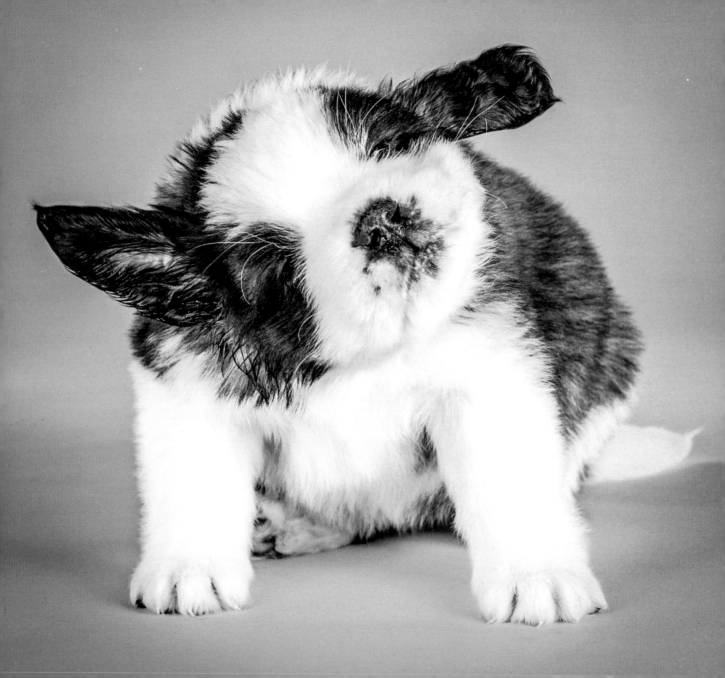

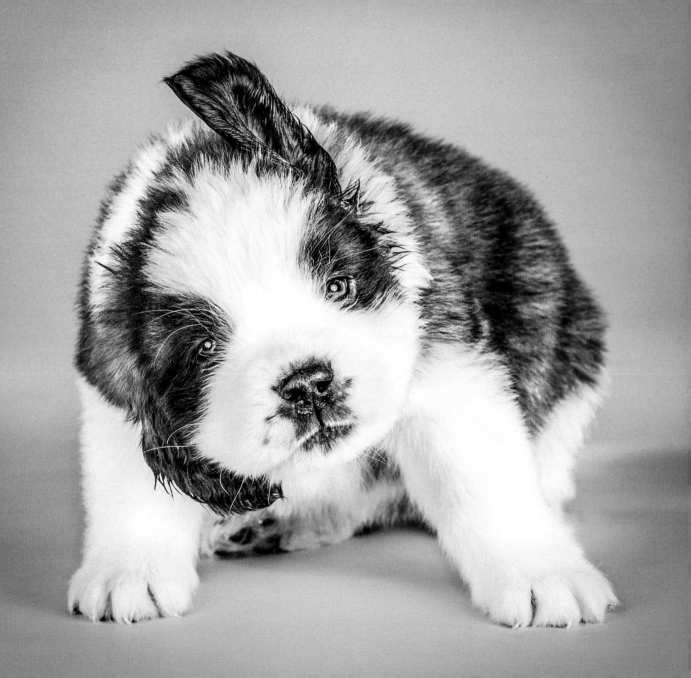

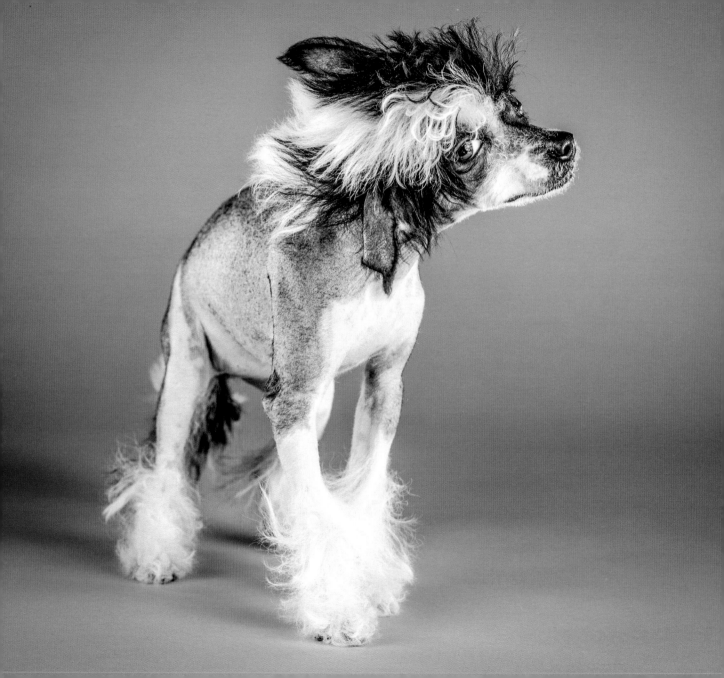

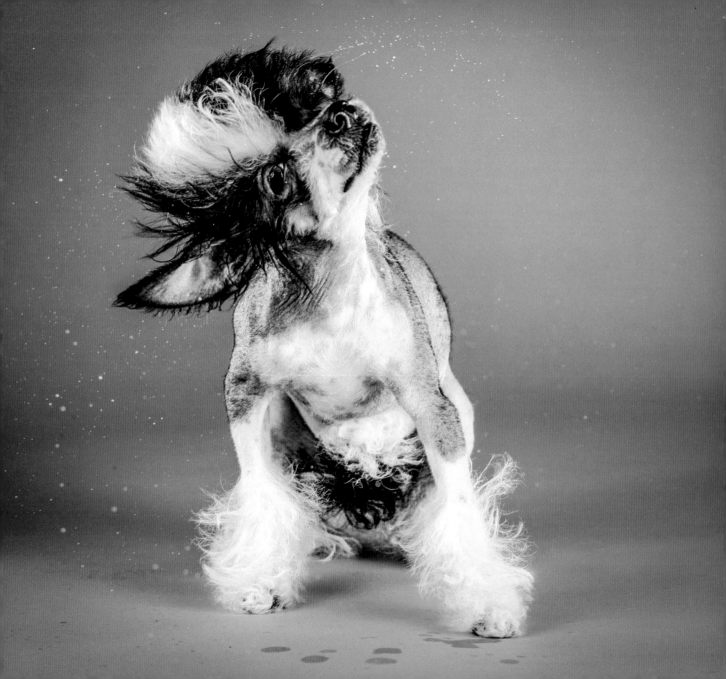

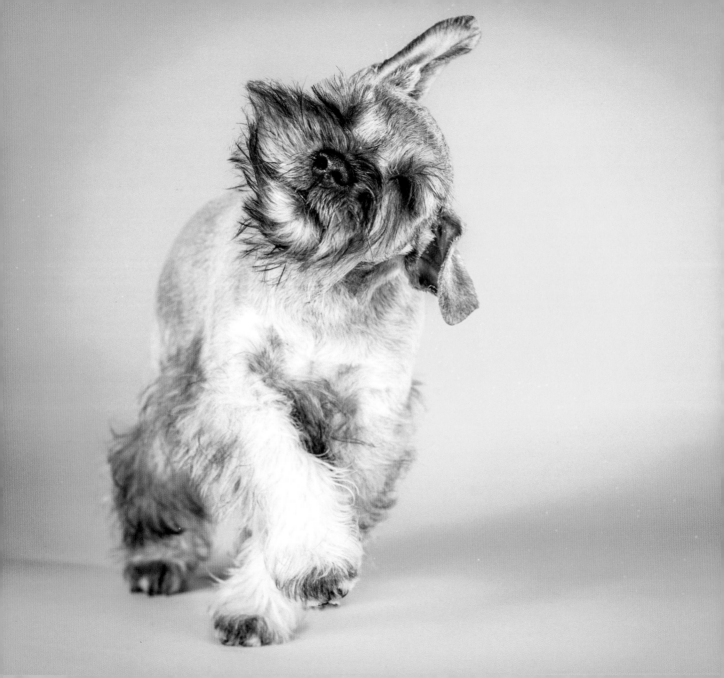

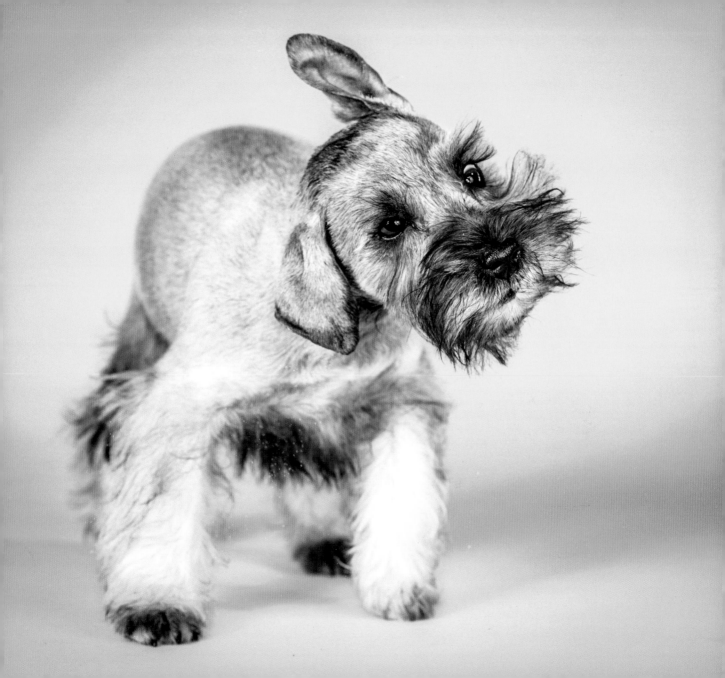

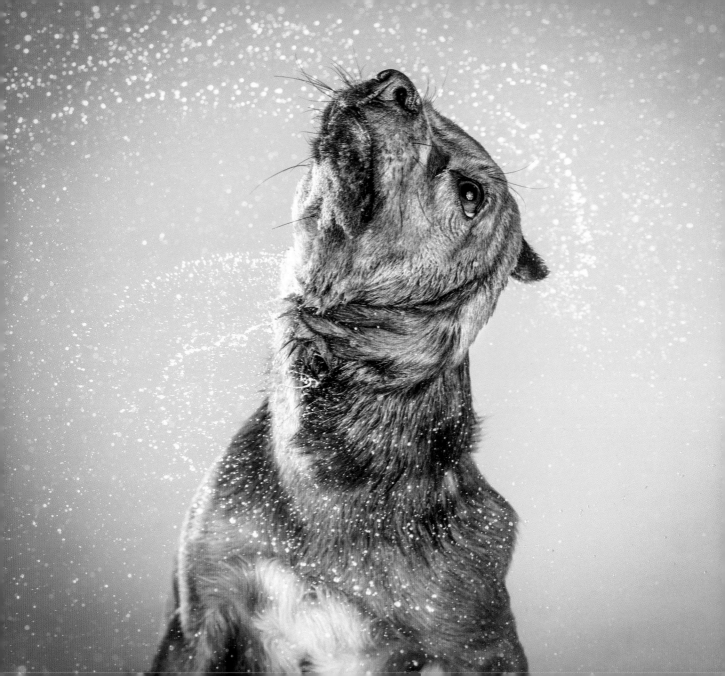

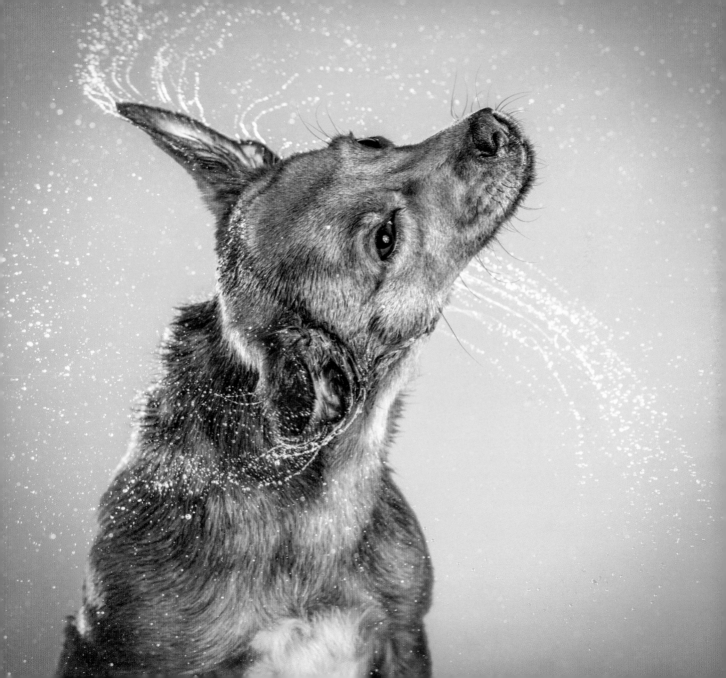

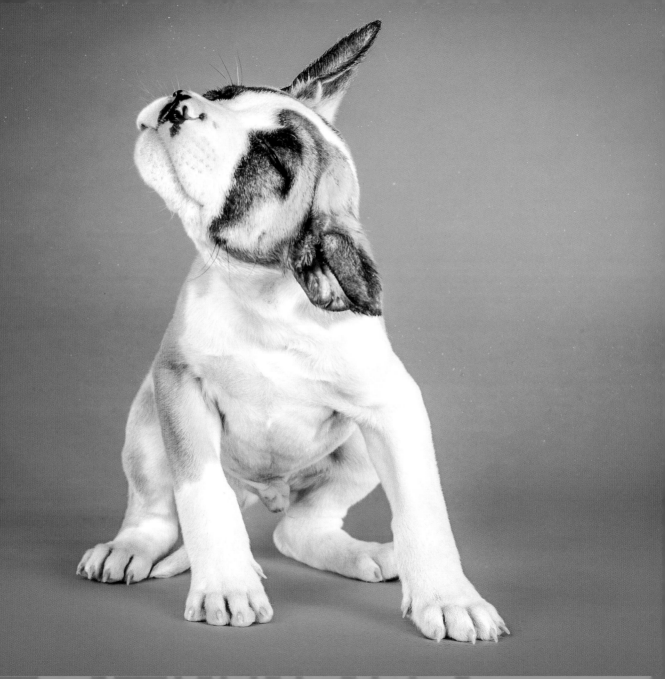

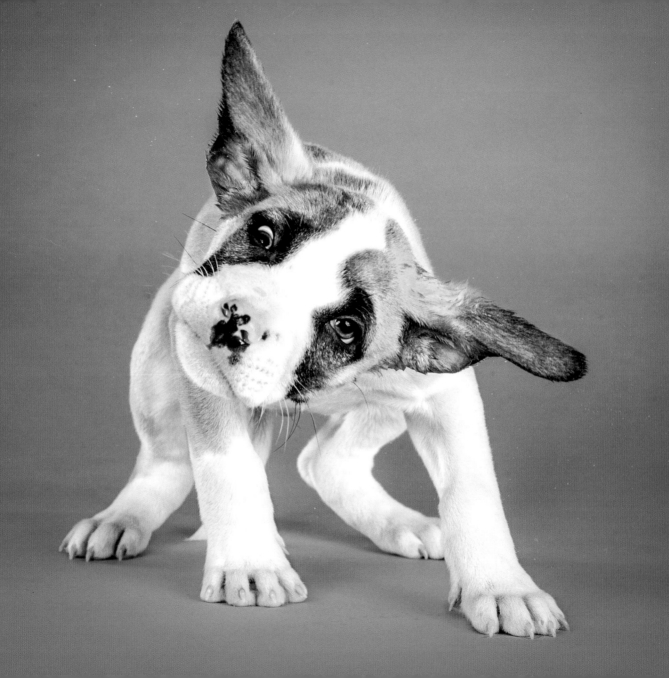

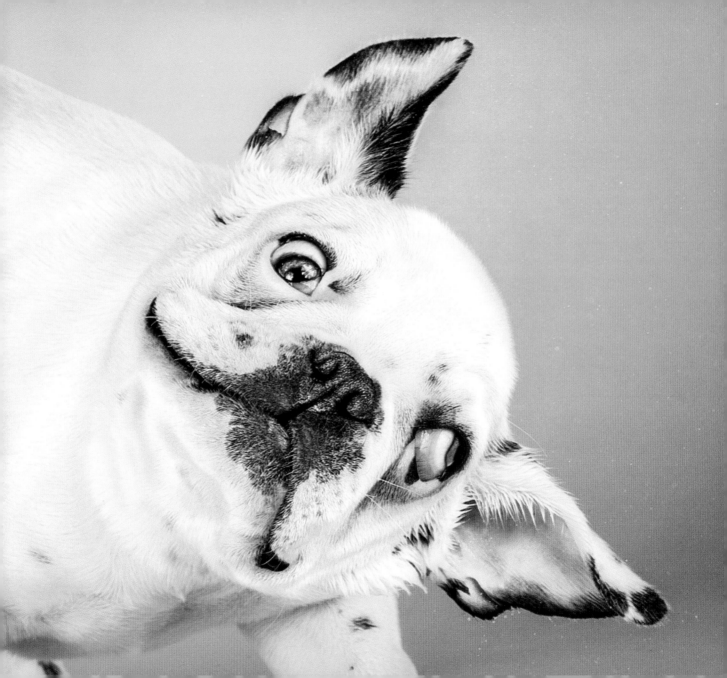

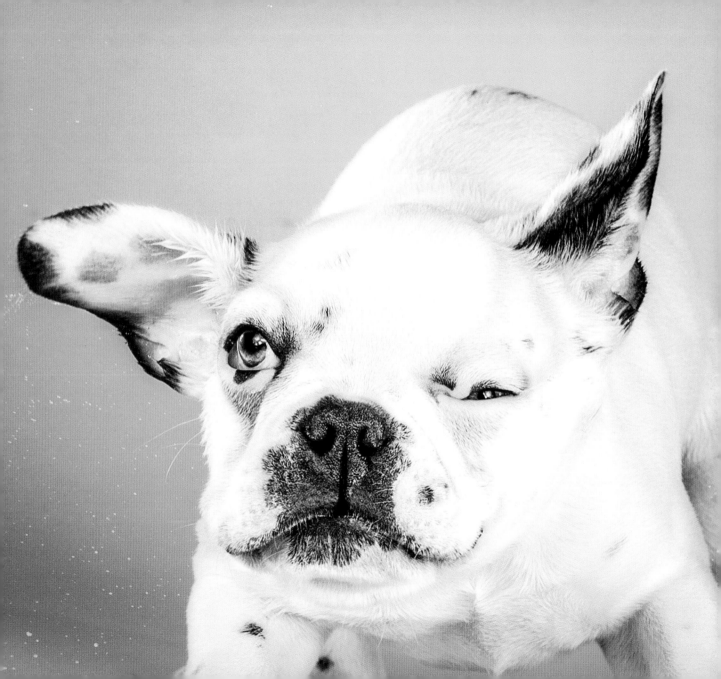

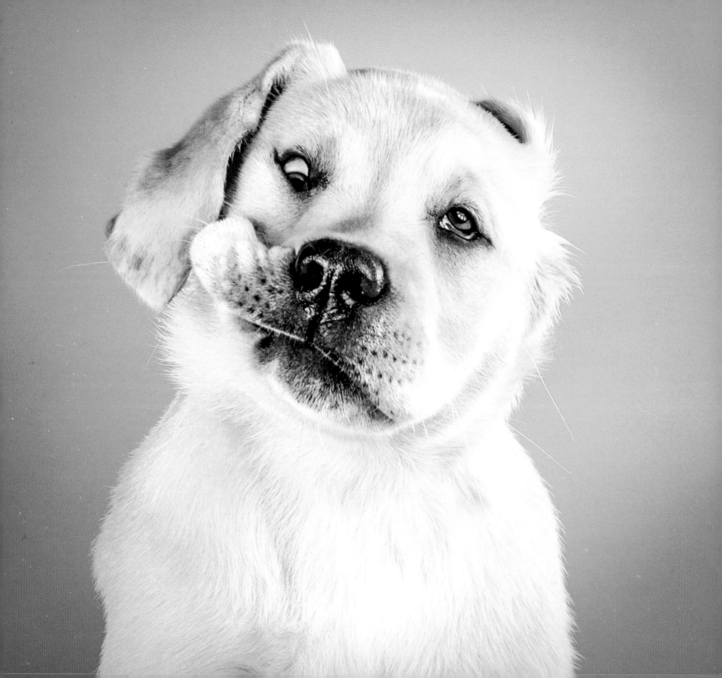

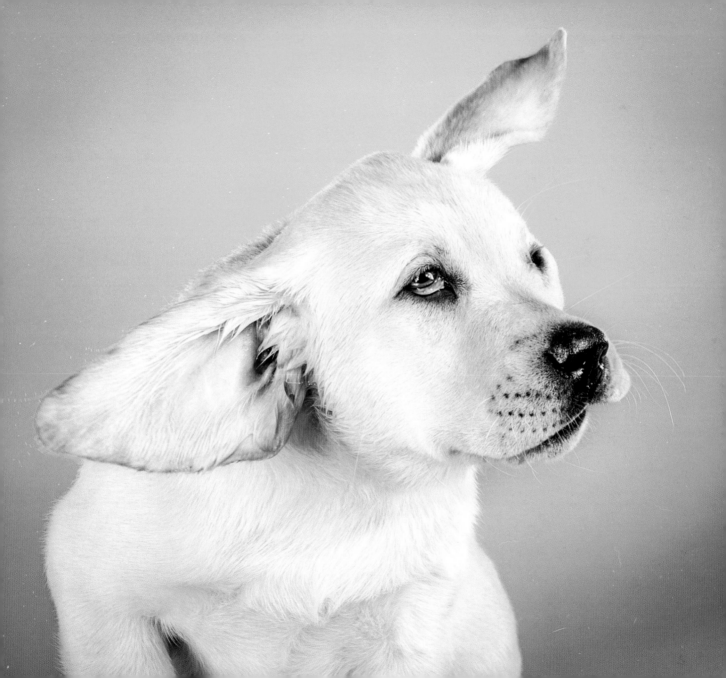

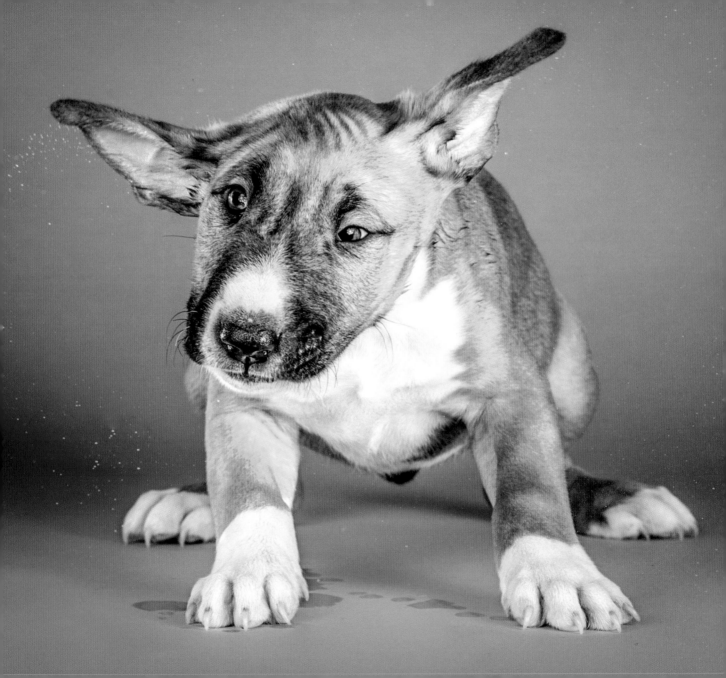

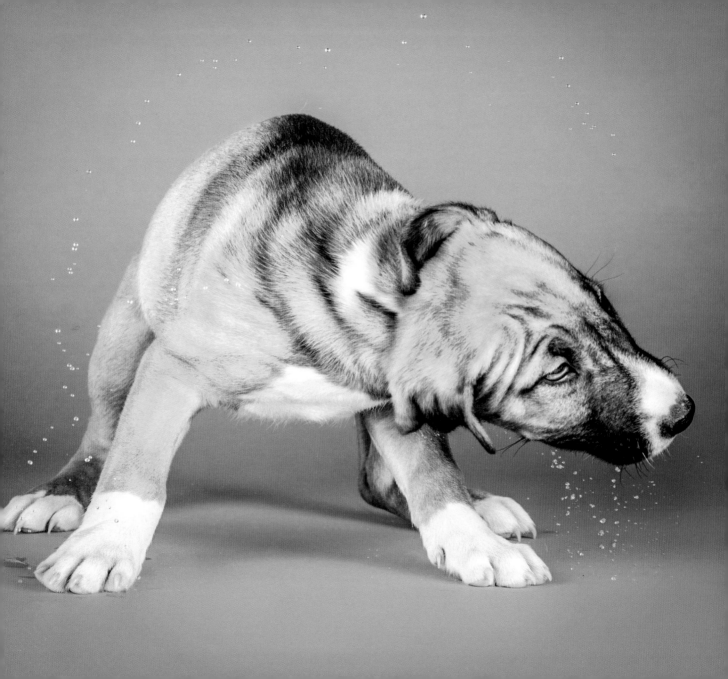

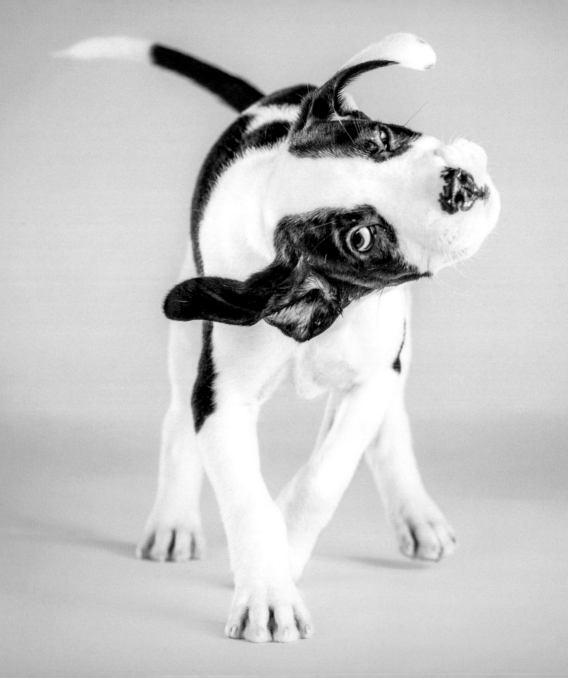

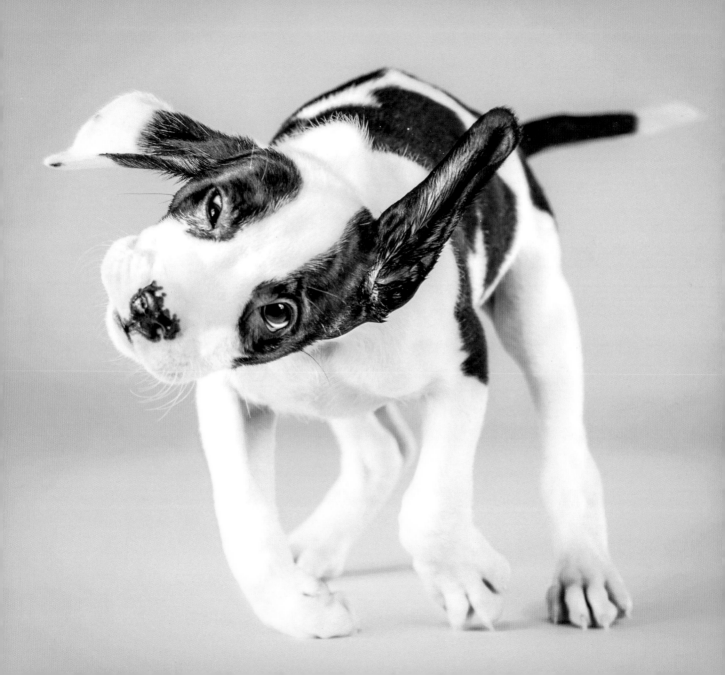

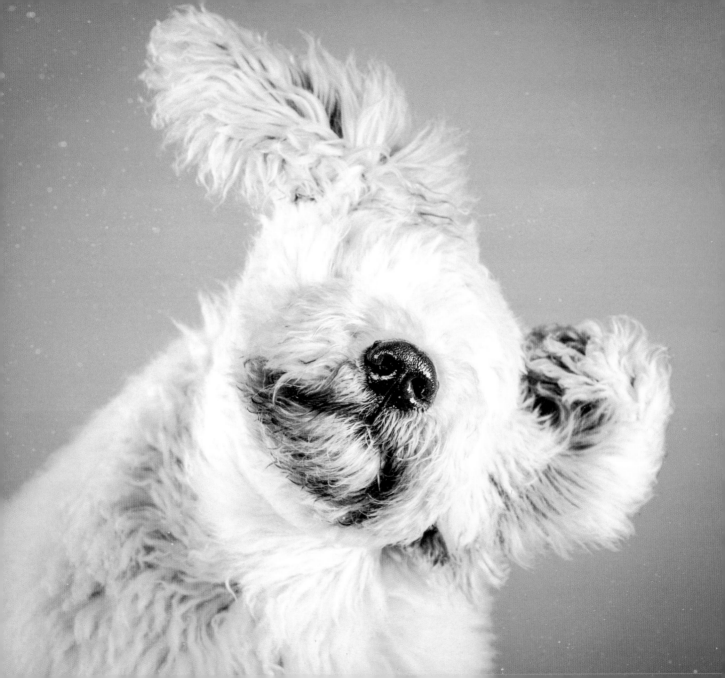

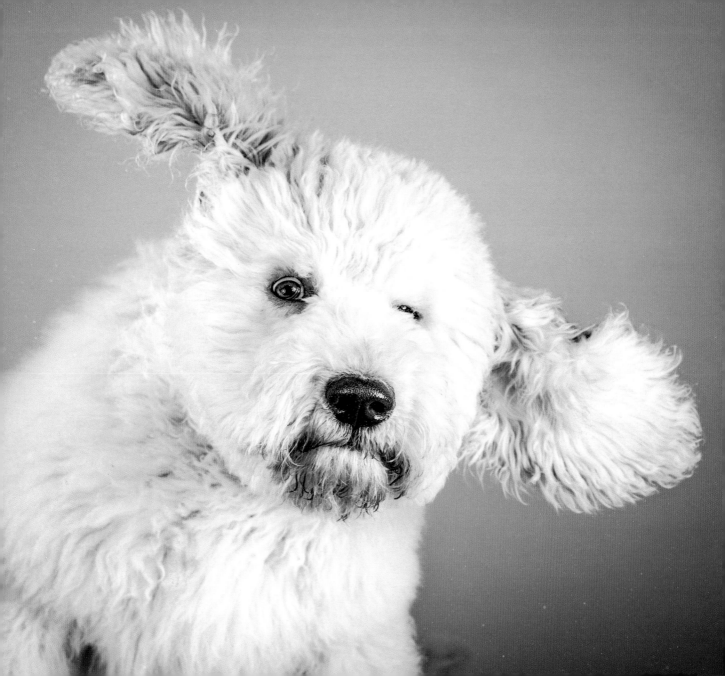

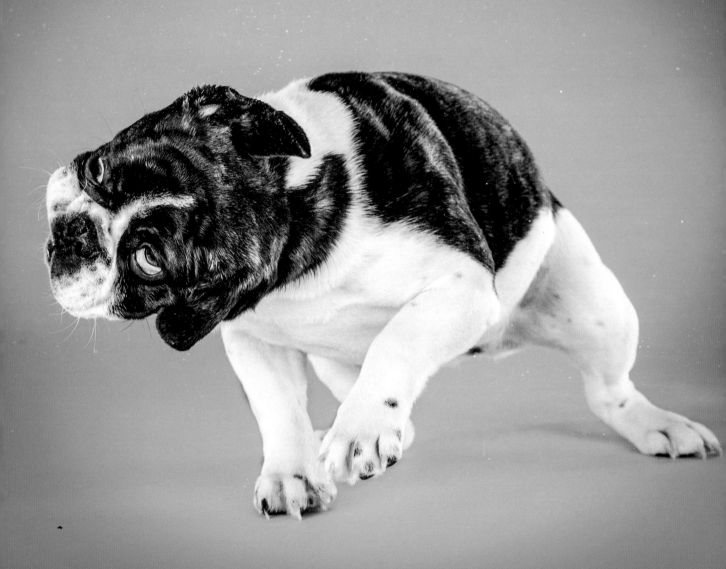

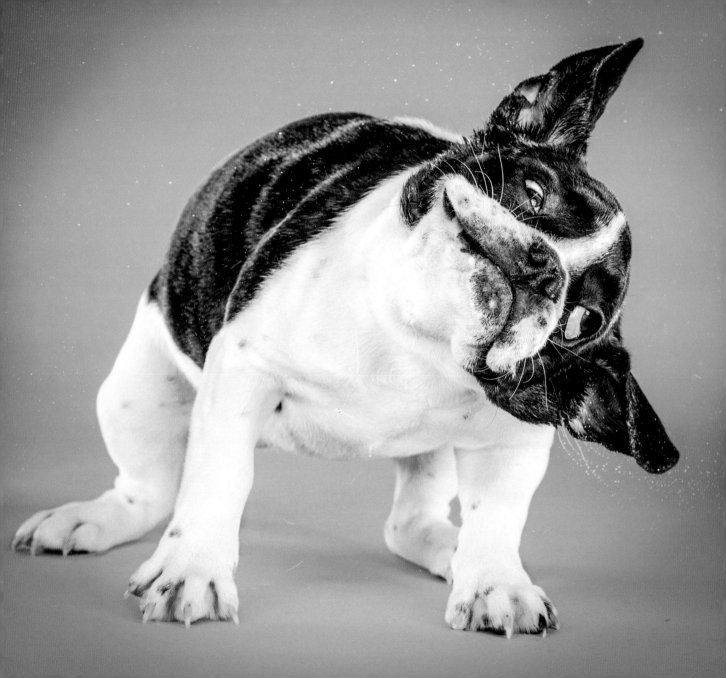

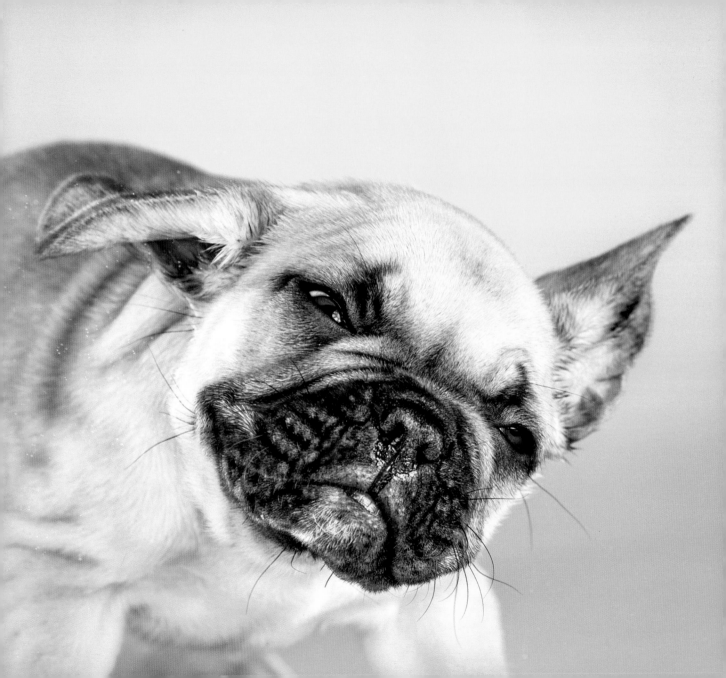

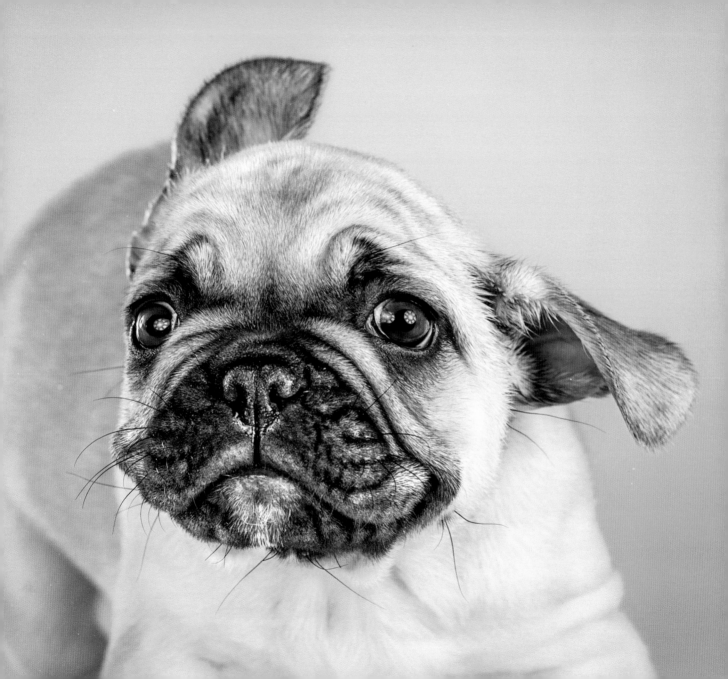

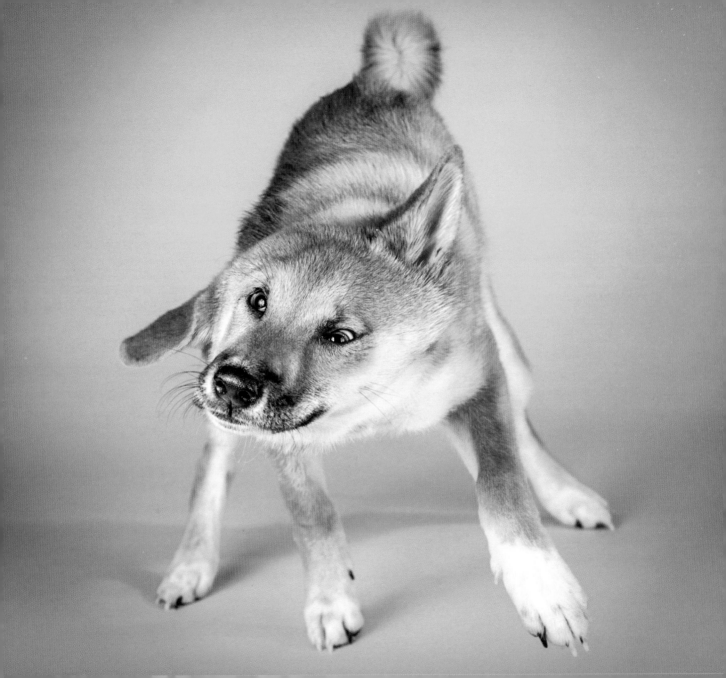

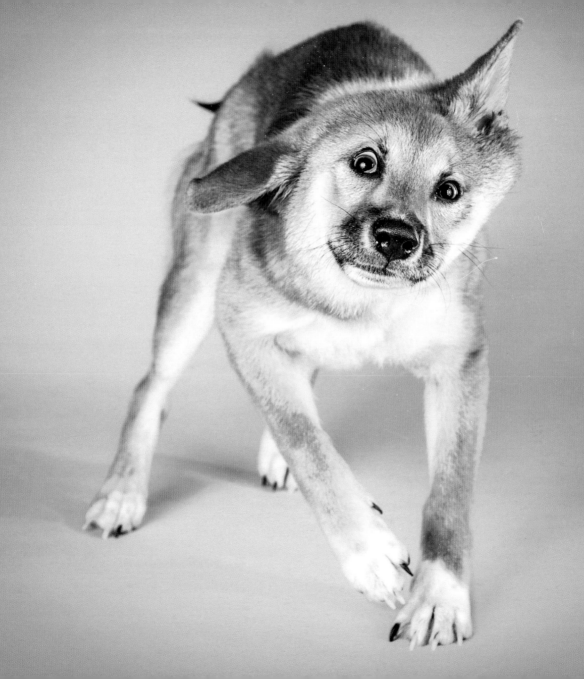

TRAIN YOUR DOG FOR TEN MINUTES A DAY

Most of the six million–plus dogs who end up in rescues every year are less than two years old. I thought of this statistic often while shooting *Shake Puppies*, since my models were in the most formative years of their lives.

The main reason young, healthy dogs are surrendered is that they lack the basic training needed to fulfill their owners' expectations of what a dog should be and how a dog should act. Since we often choose to take dogs on as pets when they are only eight to twelve weeks old, we owners need to remember that we also take on the responsibility of being their parents and mentors.

Below are five basic training skills that will help you and your dog communicate at any age. Trust me—I adopted an eight-year-old dog while shooting this book, and I needed to teach him a couple of these commands. All it takes is patience and consistency. Break it up into multiple ten-minute sessions to keep your pets interested.

Puppies grow up fast! If you're raising an eight-week-old puppy, don't wait until it's "not a baby anymore" to start its basic and house training. Start the day you get it. Babies are eager to learn, and the earlier you start training, the better you and your puppy's communication will be in the long run.

I highly recommend supporting your training by reading training books that use operant conditioning (positive reinforcement) and by taking classes. Some authors to check out are Tamar Geller, Pat Miller, Ali Brown, Patricia McConnell, Karen Pryor, the Monks of New Skete, and Jean Donaldson.

SIT: Say, "Sit," then slowly move a treat from in front of your dog's nose to over its head. The second its butt touches the ground in a sit, say "Good sit!" and reward your dog. As it gets the hang of the movement, ask it to sit from farther away without first showing it the treat.

LEAVE IT: Pick two of your pup's favorite toys. Let it play with one. Say, "Leave it" and show it the second toy. The moment it opens its mouth, praise the pup and reward it.

LEASH WALK: Put a leash on your dog in the house (always supervised) and get your pup used to feeling gentle resistance. When it walks with you, reward it with a happy voice and treats. You can start this when your pup is super young or while your adult dog is learning how to walk on leash. Slowly transition to the outdoors.

DESENSITIZE: This is a lesson that will be very important for your dog from youth into adulthood. Play with its feet, hold it, clean its ears, and bathe and groom it. Also walk it in busy neighborhoods, let it see bicycles and skateboards, and take it in the car. Get pups used to loud noises and new environments. Introduce them to little kids, cats, and any other types of animals they might end up living with.

RECALL: Say your puppy's name and show it a treat. Reward it when it comes to you and lets you touch it. As you progress, only give treats when your dog lets you grab its collar as well; this will help in emergency recall situations. Once your pup gets the hang of it, only reward it with food occasionally, but always give lots of praise.

In addition to these basic skills, puppy socialization is invaluable once your puppy has been vaccinated. Training classes for any new dog can also make a huge difference in your long-term success. Many rescues offer or can recommend local training classes.

Crate training is also an incredible tool. Getting your dog comfortable in a crate means you can leave it unsupervised in areas where there might be threats to its health, like objects that could be easily chewed or swallowed and might be toxic or obstruct your dog's bowel. Crate training could also prevent thousands of dollars' worth of home damage! In addition, travel becomes easier when your dog is crate trained.

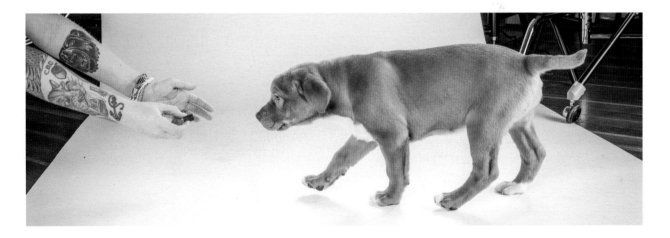

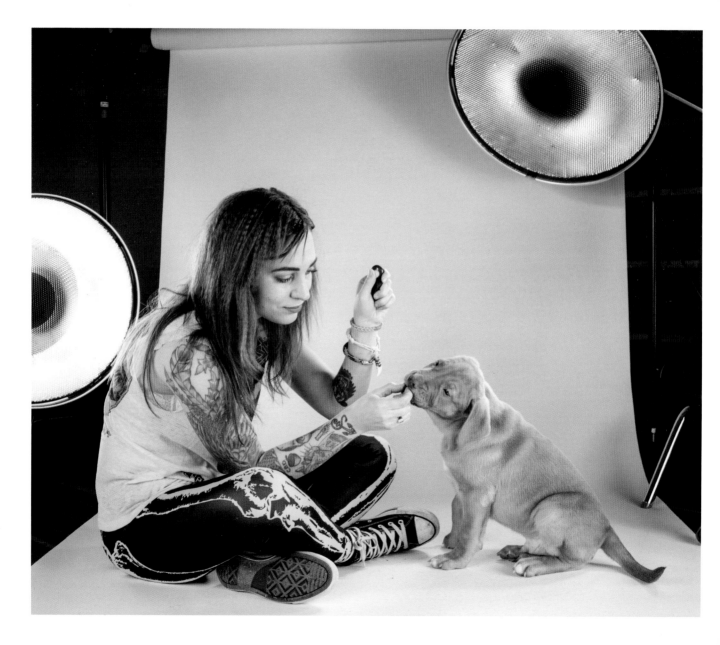

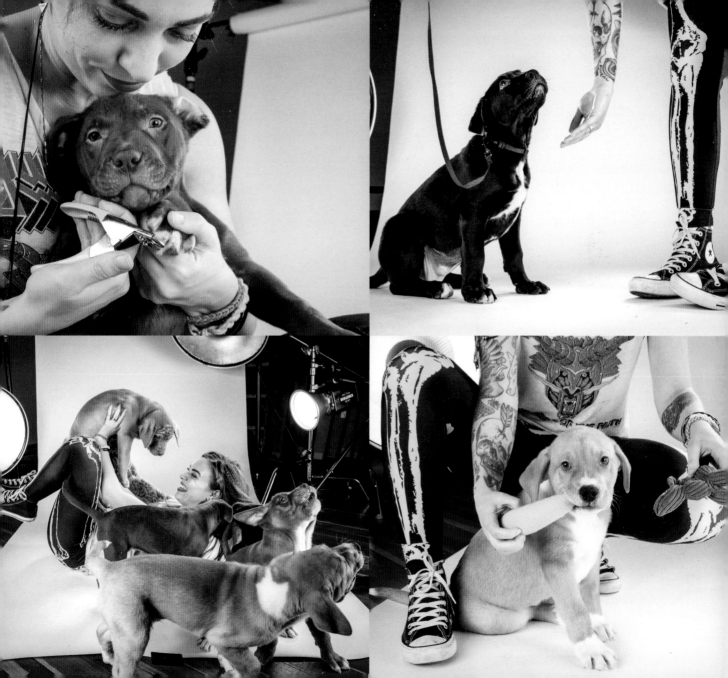

MODELS

Thank you to everyone who trusted your often TINY puppies to my vision and took the time to come to my studio. Not all of the dogs I photographed made it into the book, but their willingness to be photographed and the kindness of their owners is still greatly appreciated.

The following are the dog models in order of their appearance:

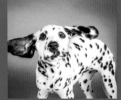

Meatball
10 weeks

Vincent
8 weeks

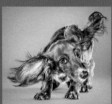

Oakland
5 weeks

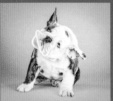

Cutlass
20 weeks

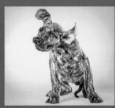

Chamomile
9 weeks

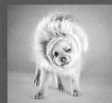

Koda
20 weeks

Hera
16 weeks

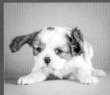

Annie
7 weeks

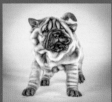

Cloud
8 weeks

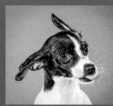

Shadow
16 weeks

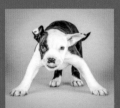

Cece
11 weeks

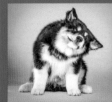

Dakota
11 weeks

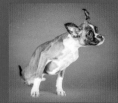

Duncan Lou Who
20 weeks

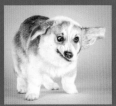

Millie
16 weeks

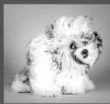

Molly
20 weeks

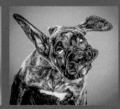

Hans
12 weeks

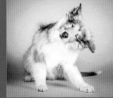

Shallowmyre
14 weeks

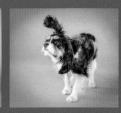

Lexi
12 weeks

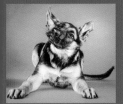
Silas
12 weeks

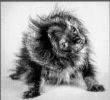
Lena
16 weeks

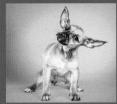
Shyla
10 weeks

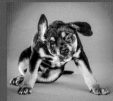
Dexter
10 weeks

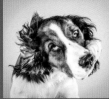
Stella
16 weeks

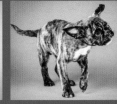
Elvis
9 weeks

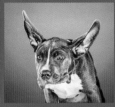
Gus
16 weeks

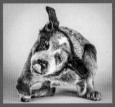
Hope
12 weeks

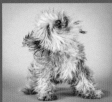
Fluffy Shark
44 weeks

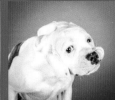
Ziggy
20 weeks

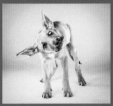
Riot
10 weeks

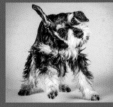
Jojo
12 weeks

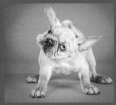
Frankie
11 weeks

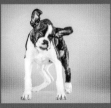
Josie
12 weeks

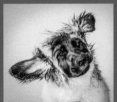
Deja
14 weeks

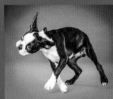
Maxwell
10 weeks

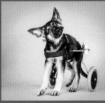
Chance
10 weeks

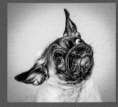
Pug Willa
13 weeks

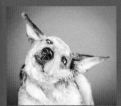
Olly
14 weeks

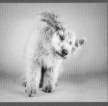
Muppet
20 weeks

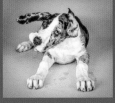
Hendrix
16 weeks

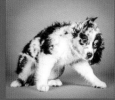
Camper
13 weeks

Tuck 'n' Roll
8 weeks

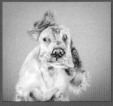
Latte
12 weeks

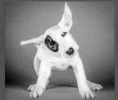
Andies
6 weeks

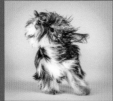
Baby
16 weeks

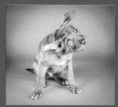
Liam
8 weeks

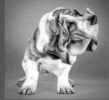
Bailey
24 weeks

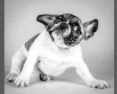
Olyvia
13 weeks

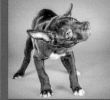
Charloette
8 weeks

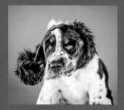
Maeve
11 weeks

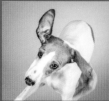
Waldo
13 weeks

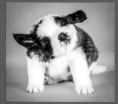
Stoans Windshadows
5 weeks

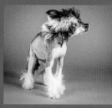
Jettah
14 weeks

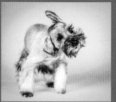
Chief Whisker Biscuit
12 weeks

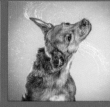
Pele
20 weeks

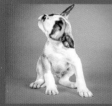
Jonny
8 weeks

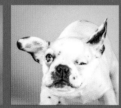
Prince Louis
16 weeks

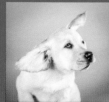
Tina Fey
9 weeks

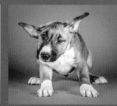
Pumpkin
6 weeks

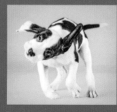
Jax
10 weeks

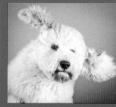
Perry
16 weeks

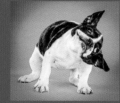
Lucy
16 weeks

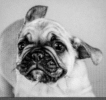
Frankie
10 weeks

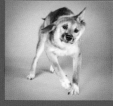
Lucia
16 weeks

Saul
418 weeks

ACKNOWLEDGMENTS

To Amanda for all the LONG DAYS locked in the studio with puppies—and bourbon hot cocoas. Also for the long days on the road lugging gear. I owe you my life for getting us home alive from Bend during that storm. Also to your family, Gary, Beast, and Jade (who also helped on-set!), for letting me hog all your time.

To Tim for always being on call to hop into the studio and give it your all, and for learning how to set everything up to make my life easier. Also for all the warm meals and love to come home to.

To my agent, Jean Sagendorph, for paving the way for me to make a living by hanging out with puppies; it's so cool!

To my editor, Julia Abramoff, for giving me the creative freedom to make some crazy books about dogs looking like cute little monsters, and my team at HarperCollins, including Lynne Yeamans, Renata Marchione, Paige Doscher, and Liz Esman.

To everyone who assisted me on-set and -off, including Tanya Paul, Michael Durham, Cindy Classen, Bree Winchell, Cheyenne Allott, Megan Adams, Michelle Borgese, Sierra Hahn, Nicole Niccasio, Giovanna Marcus, Wonder Puppy, Mt. Tabor Veterinary Care, the Oregon Zoo, Pushdot Studios, and Seth Casteel.

To the people who remind me to love life, including Andi Davidson, Michael Rudin, Jennifer Rudin, Joanne Kim, Holly Andres, Joseph Russo, Carly Chappelle, Salisha Fingerhut, Jennifer Harris, Dori Johnson, Deena Davidson, Charles Davidson, Marilyn Rudin, Leslie Davidson, Barbara Davidson, Danielle Davidson, Andy Davidson, Eric Davidson, Bob Davidson, my amazing nieces and nephews, all the Wiesches and their kin, Kuo-Yu Liang, Joe Preston, Eric Powell, Ryan Hill, Craig Thompson, Alana DaFonseca and Flip, Danica Anderson, Hukee, Carlos Donahue, Janice Moses, Krisi Rose, Randy Stradley, Matt Parkinson, Jeremy Atkins, John Schork, Mike and Bub, Greg Morrison, Carla Winch, Erica Dehil, Hannah Ingram, Scott Harrison, Jen Lin, Ali Skiba, Moira Morel, Kevin and Alissa, Lew and Alice, the Becker Family, Nikon, Sara and Lee, Marco and Andrea, Lance and Sara, the Alesandros, J. Nicole Smith, Sharon Clay, Tony Ong, Jeri Baker, Larry and Pamela, Stumptown, Nadia Buyse, Suzanne Raymond, and the wonderful crew at Variable Productions.

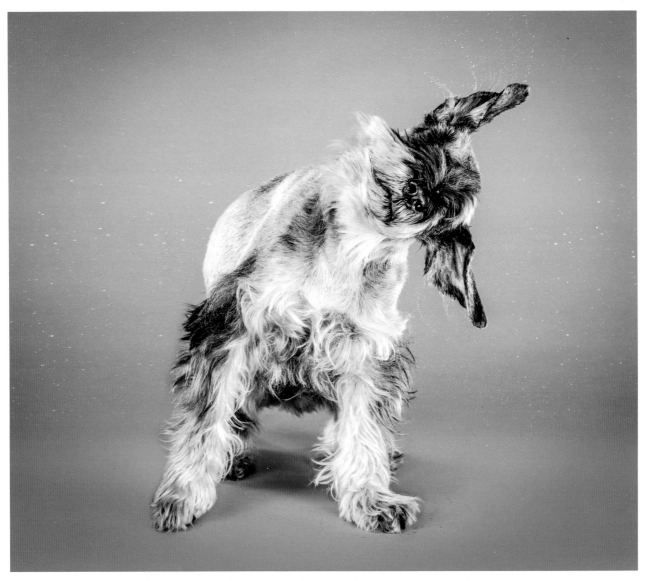

I adopted Saul during the making of this book. He's eight years old, but I had to include him since to me he's only twelve weeks.